SIGNALLING AND SIGNAL BOXES

Along the NER Routes Vol. 2

Durham, Northumberland
and Cumbria

Allen Jackson

For Ninette.

First published 2017

Amberley Publishing
The Hill, Stroud,
Gloucestershire, GL5 4EP

www.amberley-books.com

Copyright © Allen Jackson, 2017

The right of Allen Jackson to be identified as the Author
of this work has been asserted in accordance with the
Copyright, Designs and Patents Act 1988.

All rights reserved. No part of this book may be reprinted
or reproduced or utilised in any form or by any electronic,
mechanical or other means, now known or hereafter invented,
including photocopying and recording, or in any information
storage or retrieval system, without the permission in writing
from the Publishers.

ISBN: 978 1 4456 6764 5 (print)
ISBN: 978 1 4456 6765 2 (ebook)

British Library Cataloguing in Publication Data.
A catalogue record for this book is available from the British Library.

Typeset in 10pt on 13pt Celeste.
Origination by Amberley Publishing.
Printed in the UK.

Contents

Introduction	5
Summary of Contents	6
Carlisle–Newcastle	8
Northumberland	28
Cleveland, Durham Coast and Wearside	46
North Yorkshire, Teesside and Cleveland	71
References and Acknowledgements	96

Introduction

The London & North Eastern Railway (LNER) was one of the four constituents of the 'Big Four', but the identity of the larger pre-grouping companies within the LNER persisted and does so to this day. Lines are referred to by their pre-grouping ownership by Network Rail and others even now.

The only pre-grouping railways considered are those for which an identifiable signalling presence existed at the time of the survey.

Please note, the volume of the Great Eastern Railway in this series also contains information on Ways of Working and signal box lever layout and use, as well as listing and other information.

In this book the system of units used is the imperial system, which the railways themselves still use, although there has been a move to introduce metric units in places like the Railway Accident Investigation Branch reports and in the south-east of England, where there are connections to the Channel Tunnel. Distances and quantities will have a conversion to metric units in brackets after the imperial units used.

1 mile = 1.6 km, 1 yard = 0.92 m, 1 chain = 22.01 m, 1 chain = 22 yards, 1 mile = 1,760 yards or 80 chains.

Signal Box Official Title

The signal box title contained in the original Act of Parliament for the line has been used. As state education for most was not available until the 1850s, some of the titles were drafted by clerks who were either ill-educated or had received no education at all. Consequently, grammar and punctuation are sometimes present and sometimes not, in accordance with the Act as originally drafted.

Summary of Contents

North Eastern Railway (NER)

CARLISLE–NEWCASTLE
Corby Gates
Brampton Fell
Milton
Low Row
Haltwhistle
Bardon Mill
Haydon Bridge
Hexham
Prudhoe
Wylam
Blaydon

NORTHUMBERLAND
Newsham
Bedlington South
Bedlington North
Marcheys House
Winning
Freemans
North Seaton
Ashington
Morpeth
Alnmouth
Chathill

TEES VALLEY–DURHAM
Heighington
Shildon
Norton West
Norton South
Norton East
Norton on Tees
Billingham
Belasis Lane
Greatham
Cliff House
Clarence Road
Cemetery North
Dawdon
Seaham
Hall Dene
Ryhope Grange Junction

CLEVELAND
Bedale
Low Gates
Urlay Nook
Bowesfield
Tees Yard
Middlesbrough
Nunthorpe
Whitehouse
Grangetown
Redcar
Longbeck
Crag Hall

Carlisle–Newcastle

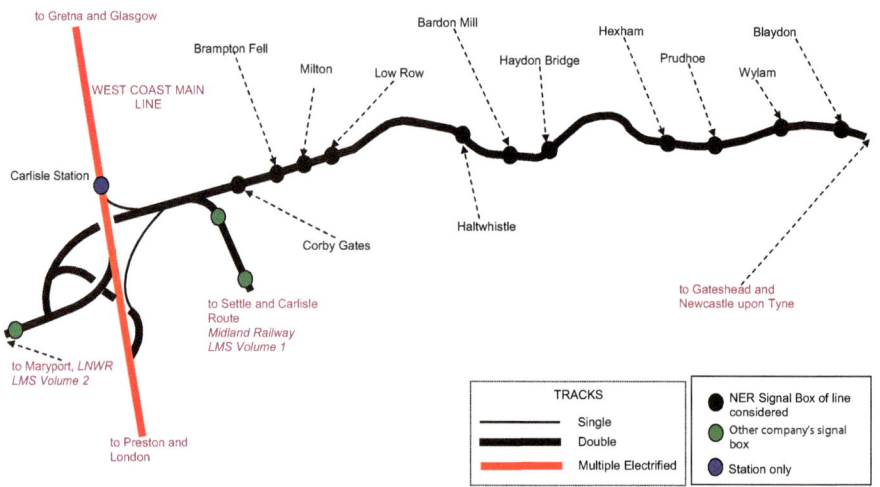

Fig. 1. Carlisle to Newcastle.

The schematic not-to-scale diagram at Fig. 1 in no way depicts the scenic grandeur of the line and its proximity to Hadrian's Wall.

Carlisle has been a fortress for centuries – indeed, the city's station was named Citadel until recent years – and this is exemplified in Maurice Grieffenhagen's railway poster for the LMS in 1924, which is now part of the NRM collection.

Newcastle upon Tyne was a leviathan of heavy industry in the nineteenth century, underpinned by coal mines surrounding the city. Ship-building and heavy engineering, including armaments and railway locomotive manufacture, all featured in Newcastle's portfolio, as well as being a prime exporter of coal at the port on the River Tyne. The NER enable access to the Cumbrian coast's iron ore field as a lucrative trade.

The journey begins on the scenic Eden Valley just east of Carlisle and mileages are calculated from Newcastle Central station, which is regarded as the Up direction.

Corby Gates (CG)

Date Built	NER Type or Builder	No. of Levers and/or Panel	Ways of Working	Current Status (2015)	Listed Y/N
1955	BR North Eastern Region Type 17	26	AB	Active	N

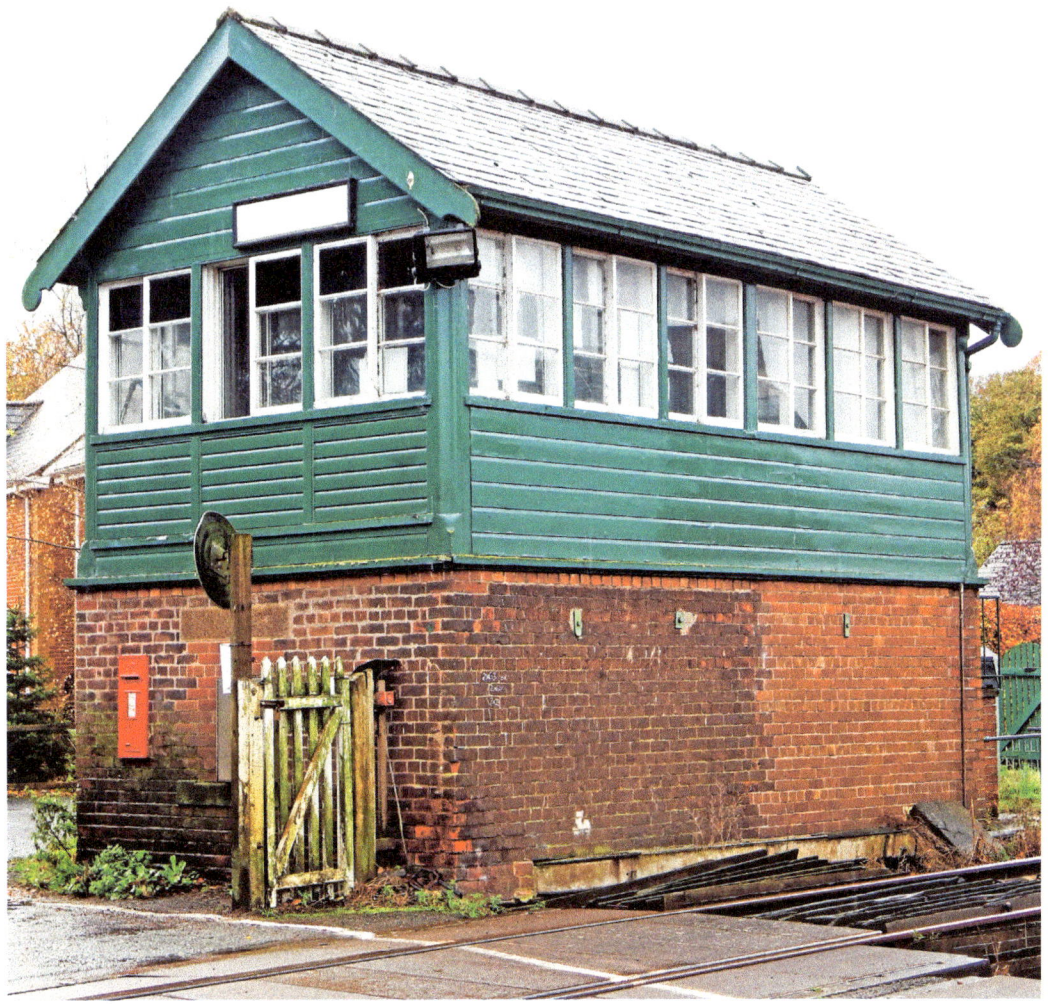

Fig. 2. The tradition of melding on a postbox has been continued. This signal box was an early recipient of barriers and as such had flashing lights and sirens that only operated as the barriers were being lowered and not before, as are commonplace now. (November 2015).

The signal box has a faintly Victorian air about it despite being from the 'You've Never Had it So Good' era of a post-Second World War government.

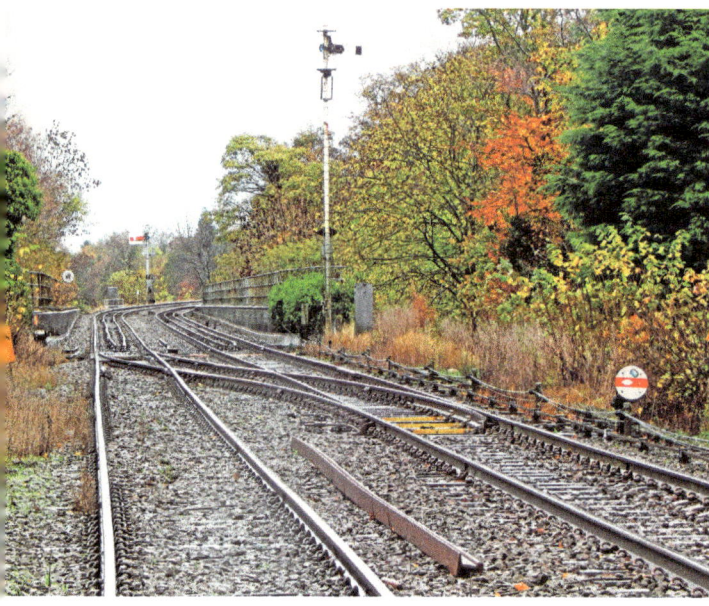

Fig. 3 is the view towards Wetheral station, Carlisle and the viaduct, from the crossing. The station is about 0.25 miles (400 metres) from the station across the river. Note the twin check rails inside the running rails to retain any vehicle that has become derailed on the viaduct and to prevent the far more serious incident of a vehicle toppling into the river. The track-circuited ground disc would suggest passenger trains could reverse here. (November 2015).

Fig. 4 is GB Railfreight Class 66 No. 66735 coming off Wetheral Viaduct into the station with a coal train, ironically, bound for Newcastle. This route is used more for coal trains if the Settle & Carlisle route is under repair or maintenance. There were up to thirty-five freights a day on the line, rising to sixty-five when the S&C is unwell. (November 2015).

Corby Gates signal box is 55 miles and 54 chains (89.6 km) from Newcastle Central station.

10

Brampton Fell (BF)

Date Built	NER Type or Builder	No. of Levers and/or Panel	Ways of Working	Current Status (2015)	Listed Y/N
1918	NER Type N4+	20	AB	Active	N

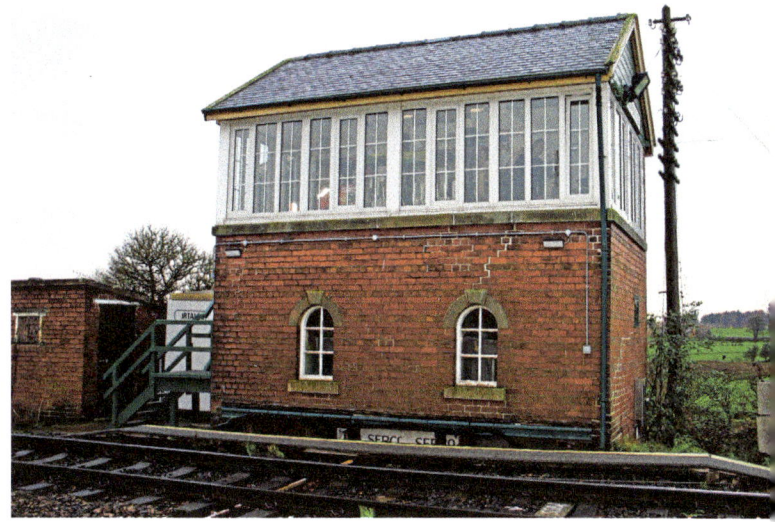

Fig 5. Brampton Fell signal box. The box belongs to the northern division of the NER and is typecast as such. Note the now-redundant 'pole route' of a telegraph pole with the pot insulators. (November 2006).

In common with many other locations, the signal box does double duty in supervising a road crossing.

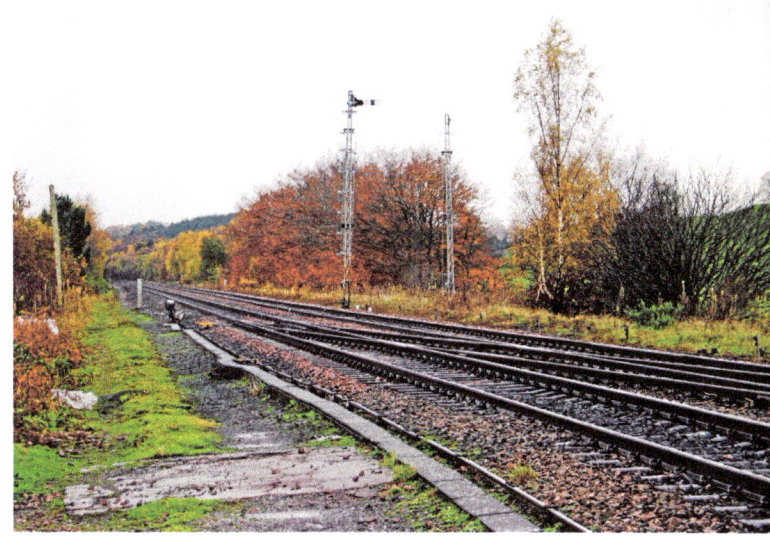

Fig. 6 is the opposite way towards Carlisle and it looks as though a replacement semaphore post is in the offing. Both are lattice post types. The semaphore signalling here has been replaced but the box survives as of November 2015. (November 2006).

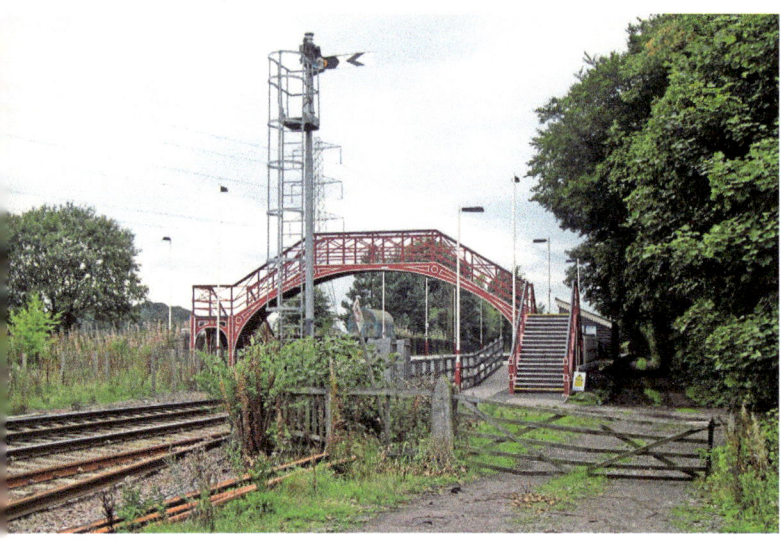

Fig. 7 is a view of Brampton station, or Brampton Junction as it was, with Milton's semaphore distant signal standing guard. Milton signal box is about 0.75 miles (1.2 km) from Brampton station. The view is towards Brampton Fell signal box and Carlisle. (November 2006).

Brampton Fell signal box is 50 miles and 10 chains (80.67 km) from Newcastle Central station.

Milton (–)

Date Built	NER Type or Builder	No. of Levers and/or Panel	Ways of Working	Current Status (2015)	Listed Y/N
1893	NER Type N2	10	Gate	Active	Y

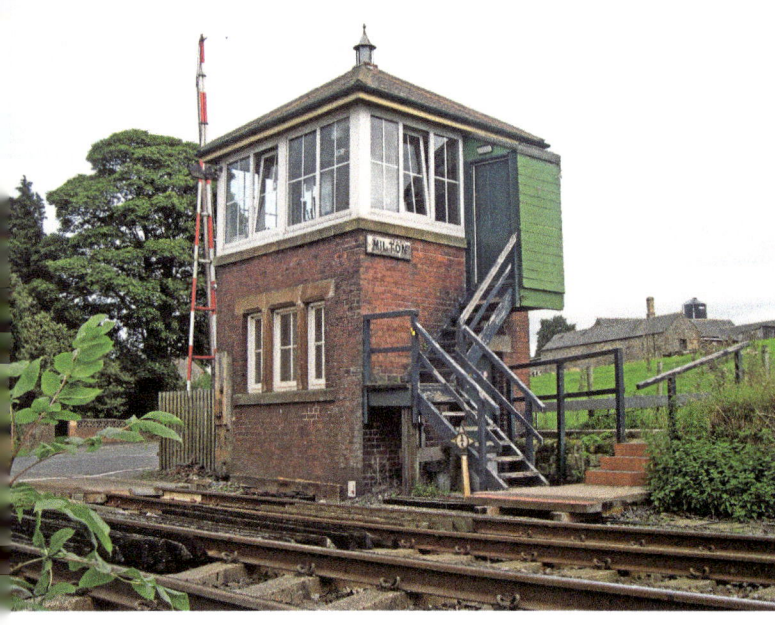

Fig. 8. The gate wheel and gates have been replaced by lifting barriers. Milton signal box retains the characteristic NER turned wooden steps as well as the NER cast-iron quarter-mile post marker. The value on the post is three quarters, which matches up exactly with the 60 chains (1.2 km) on official records, and the three spikes on the sign also signify three quarters. (September 2006).

Milton has always been a gate box and has survived the recent cull of crossings and their manual facilities.

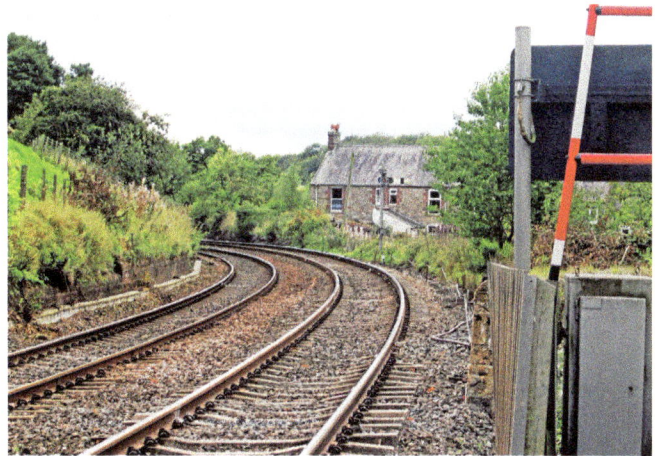

Fig. 9 is the home signal whose distant was mentioned in Fig. 7 and consequently the view is back towards Brampton station and Carlisle. The cottages look as though they may well have been railway worker's dwellings. (September 2006).

Brampton Fell signal box is 48 miles and 60 chains (78.45 km) from Newcastle Central station.

Low Row (LR)

Date Built	NER Type or Builder	No. of Levers and/or Panel	Ways of Working	Current Status (2015)	Listed Y/N
circa 1871	NER Type N1	29	AB	Demolished 2009	N
2009	Network Rail Gabled	Nx Panel		Replacement is Active	N

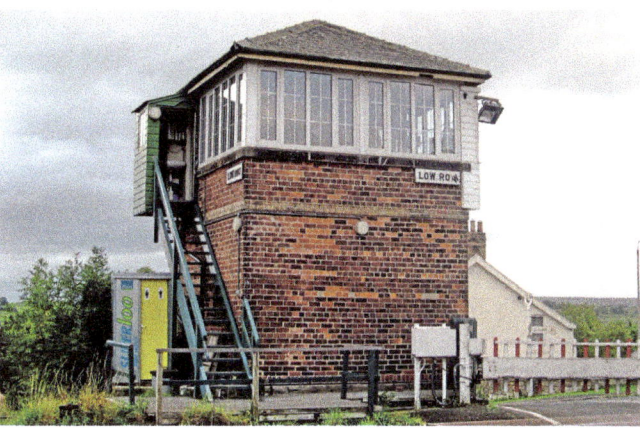

Fig. 10. The old Low Row signal box, which is at a junction of minor roads off the A69 Carlisle to Newcastle road. The motorised boom crossing gates are still in place and the only concession to the twenty-first century is the SuperLoo outside the box. Even the road sign is a cast-iron production from another era; the 1950s probably. (September 2006).

13

Low Row signal box was an ancient and historic structure but it fell foul of a local resignalling scheme in later years that partly modernised the signalling at Brampton Fell, Low Row and Haltwhistle.

Fig. 11 is still early days with the view towards Carlisle. A lattice post home signal guards the Up line side of the crossing. The ground disc signals reversing moves over the trailing crossover, which is the other side of the crossing, and so the signal appears to be motorised to save having rodding going under the crossing. Note the small yellow light issuing from the rear of the signal. When the signal is operated this is covered up by the small white arm, which rotates, and so indicates to the signaller at night that the signal has operated. This light is called a backlight and the small arm either a backlight cover or 'blinder'. (September 2006).

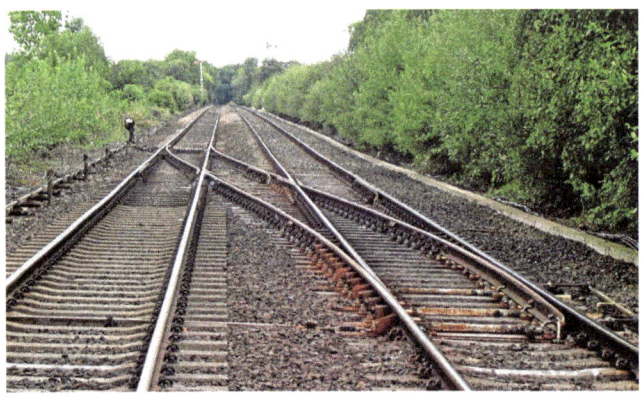

Fig. 12 is a fairly agricultural view of the line towards Newcastle and the crossover referred to in the previous figure. The bracket signal for the Down line towards Carlisle has almost disappeared in the undergrowth. (September 2006).

14

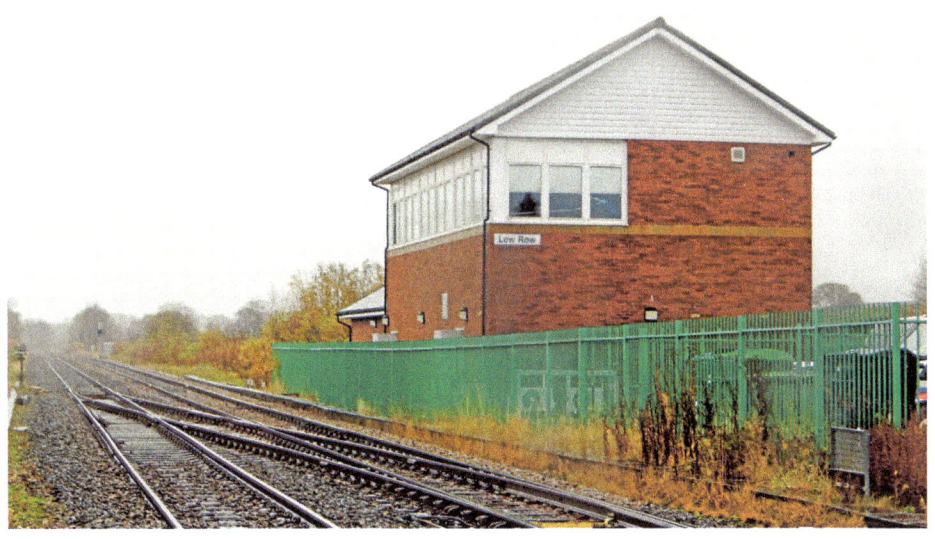

Fig. 13 is the updated version of Low Row in Network Rail style and the building is still recognisable as a signal box. However, the semaphore signals have been removed and the crossover is now worked by electrical power. (November 2015).

The original Low Row signal box was 46 miles and 24 chains (74.51 km) from Newcastle Central station and the newer version is about 3 chains (61.38 metres) nearer to Newcastle.

Haltwhistle (HW)

Date Built	NER Type or Builder	No. of Levers and/or Panel	Ways of Working	Current Status (2015)	Listed Y/N
Not known	NER Type Non Standard	61	AB	Closed	Y
1993	Portakabin	Nx Panel		Replacement is Active	N

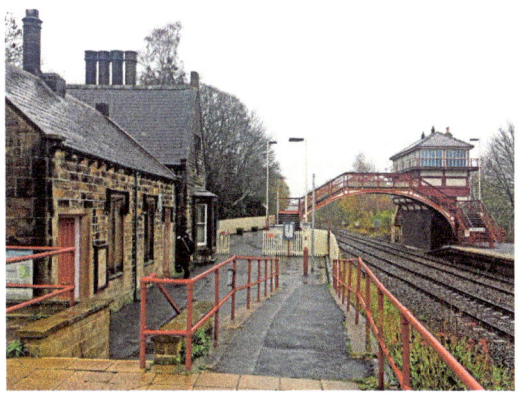

Fig. 14. The older Haltwhistle signal box and station building. The original box is quite unlike any other NER signal box and lives on in refurbished comfort. The NER footbridge and station building complete the scene. (November 2015).

Haltwhistle's original signal box is listed and included. This is another 'two for the price of one situation', as we saw at Low Row, except that both signal boxes survive at the time of writing.

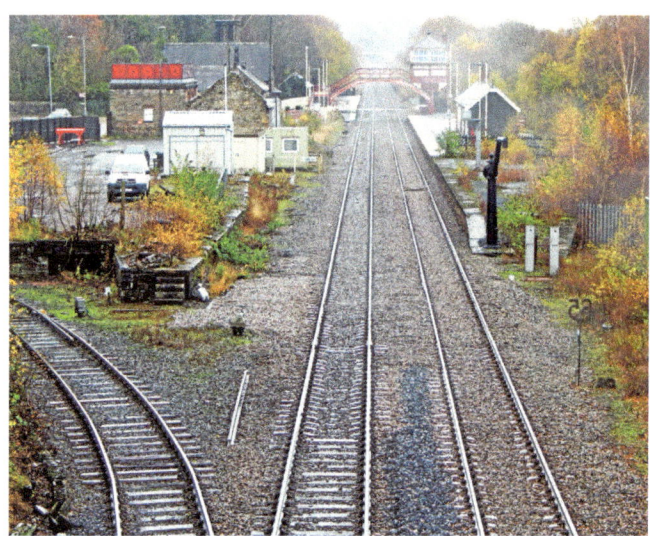

Fig. 15 is a view from the West Road bridge and the newer box is opposite the Midland Railway-style paling wooden fencing on the right-hand platform in the green/grey colour. The steam-age water crane and water tower seem to insist that the newer structure is an imposter. Note the electrically operated trap point on the engineer's siding and the goods loading dock, which is close to the site of the extensive goods shed. (November 2015).

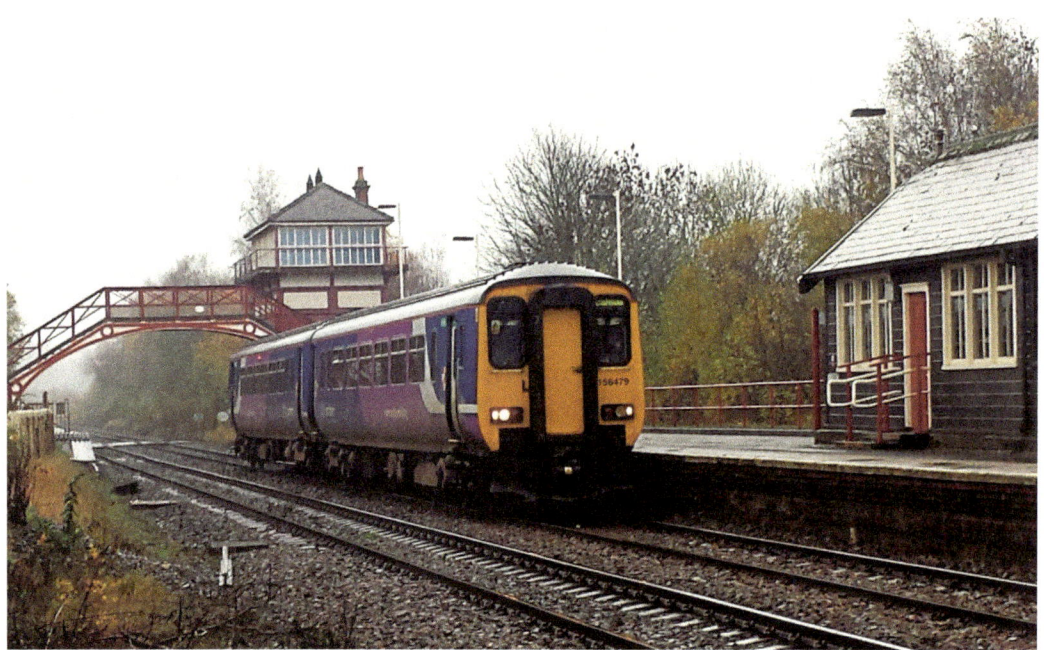

Fig. 16 is right by the newer signal box but is looking across to the staggered Carlisle platform. Class 156 No. 156479 draws into the still-used part of the Down platform. Note the NER waiting shelter on the right-hand side. At one time this platform was an island and the far side accommodated the Alston-bound trains. The signals here are of the high intensity LED-type colour light signals. (November 2015).

The newer Haltwhistle signal box is 37 miles and 20 chains (59.95 km) from Newcastle Central station and the original box is about 3 chains (61.38 metres) nearer to Newcastle.

Bardon Mill (BM)

Date Built	NER Type or Builder	No. of Levers and/or Panel	Ways of Working	Current Status (2015)	Listed Y/N
circa 1874	NER Type N1	20	AB	Not Normally Active	N

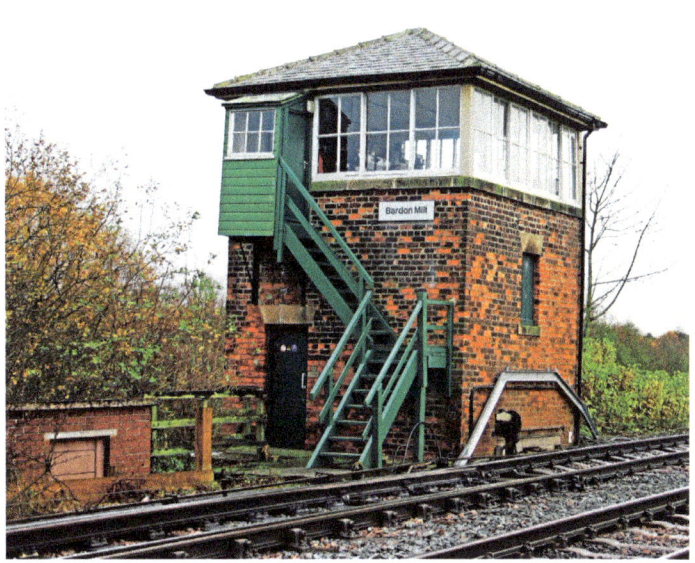

Fig. 17. The crossover right by the box was no longer there in November 2015 but at the original survey date the ground disc lamps were both marked LNER, although they had been converted to electric operation at some point. (November 2006).

Bardon Mill signal box has been switched out for many years but still clings on.

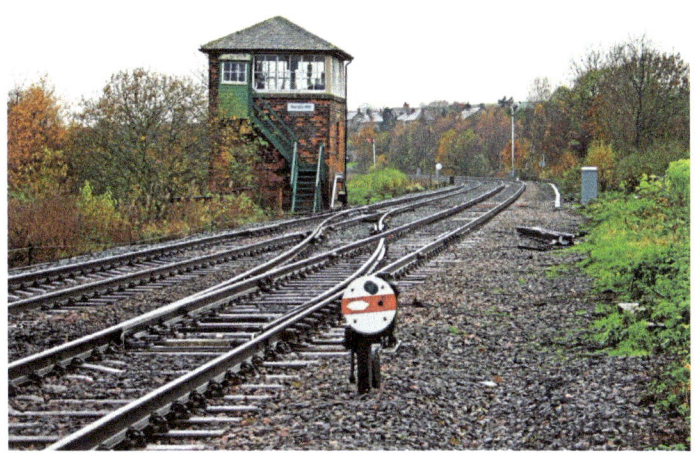

Fig. 18 and Bardon Mill signal box appears to be switched out with both Up and Down home signals pulled off. The crossover hasn't much longer to go as the nearer point has had the crossing frog removed and is plain-lined. (November 2006).

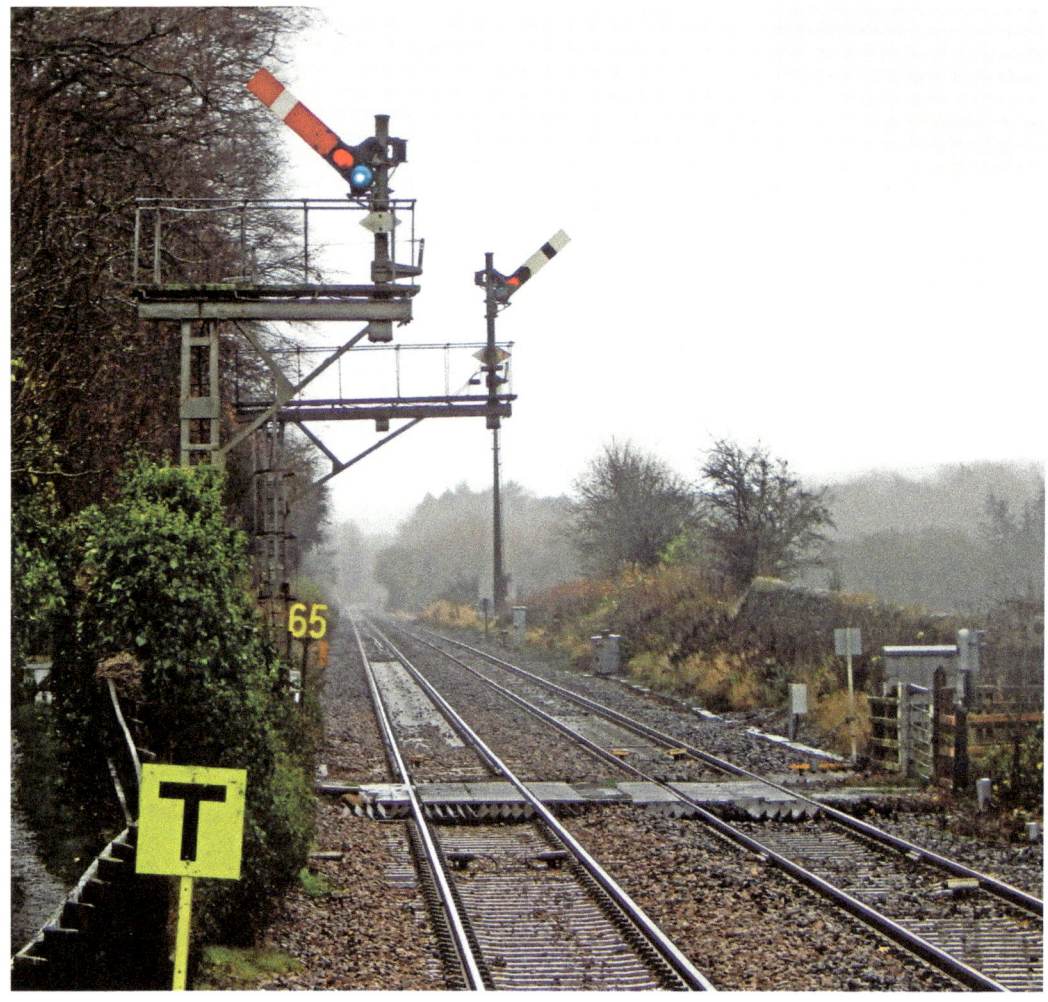

Fig. 19 was taken from the platform at Bardon Mill station and is further affirmation that the box is switched out with both bracket signals off. The raging cauldron that is the River Tyne is in full spate to the right, down the embankment. The 'T' symbol on the trackside sign is the termination of a speed restriction. Presumably the headlight from the train illuminates such signs at night. Just by the Up platform, but not on it, are the NER stationmaster's house and a large timber NER waiting room. The latter is now in use as holiday accommodation. (November 2015).

Bardon Mill signal box is 32 miles and 41 chains (52.32 km) from Newcastle Central station.

Haydon Bridge (HB)

Date Built	NER Type or Builder	No. of Levers and/or Panel	Ways of Working	Current Status (2015)	Listed Y/N
circa 1877	NER Type N1	31	AB	Active	N

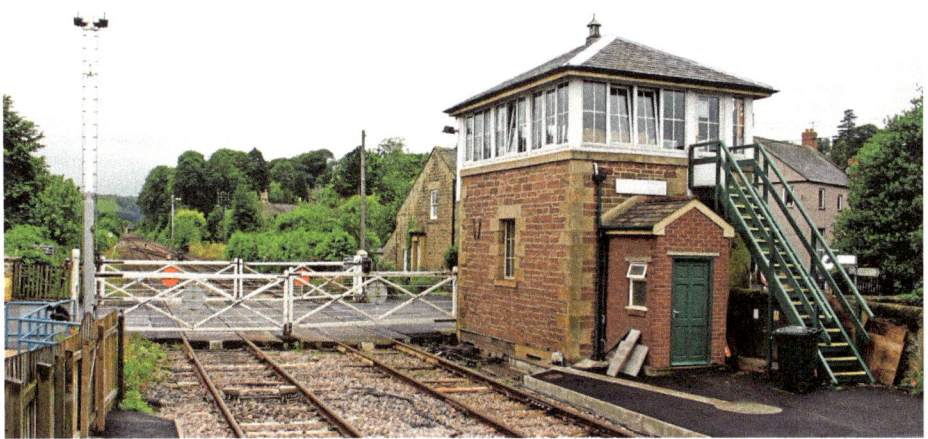

Fig. 20. At the time of the photograph, Haydon Bridge still had a gate wheel and the gates were opened and closed from within the signal box mechanically. The box is unusual in being built of stone. The brick-built outhouse attached to the box does not seem in keeping and may have been ruled 'offside' if the box had been listed. There are two 'CN WILKINSON' signs here either side of the crossing and across the road. The view is from the Down platform at the station and towards Carlisle. (July 2008).

Haydon Bridge, unsurprisingly, is known for its crossing of the River Tyne, although the original picturesque crossing is now limited to pedestrians. The Norman church in the village was an early recipient of recycled stone from nearby Hadrian's Wall.

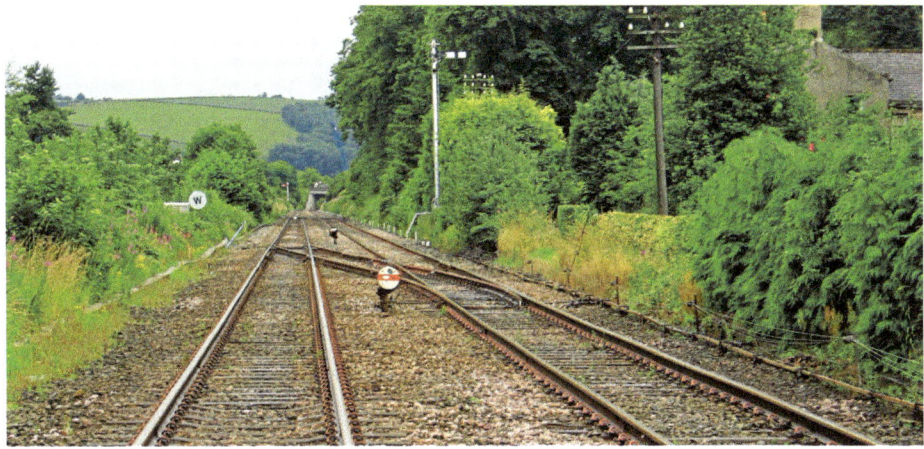

Fig. 21 is beyond the crossing towards Carlisle and the bridge in the distance is the main Carlisle to Newcastle road, the A69, and beyond that is the River Tyne. Note the pole route for telegraph poles still standing, although without any telephone wires between the pot insulators. Some telegraph poles are retained to ferry mains cables in rural areas, as here. The 'W' sign stands for 'Whistle' and it's a long time since most rolling stock could do that, but the terminology is retained as the cost of change outweighs any benefits. The near semaphore signal post is grey on the lower portion. This is a Network Rail innovation, although there are plenty of signals on the network that are black on the lower half instead. (July 2008).

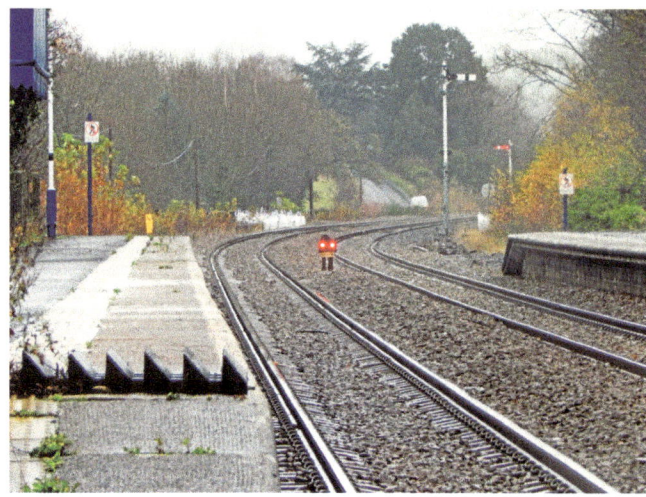

Fig. 22 is a more modern view with LED ground signal, which is used to signal a reversing move into an engineer's siding. There are still some semaphores on the way to Newcastle. The waiting shelter on the platform on the left would appear to be an NER original. (November 2015).

Haydon Bridge signal box is 28 miles and 35 chains (45.76 km) from Newcastle Central station.

Hexham (HM)

Date Built	NER Type or Builder	No. of Levers and/or Panel	Ways of Working	Current Status (2015)	Listed Y/N
1918	NER Type N5 Overhead	60	AB	Active	Y

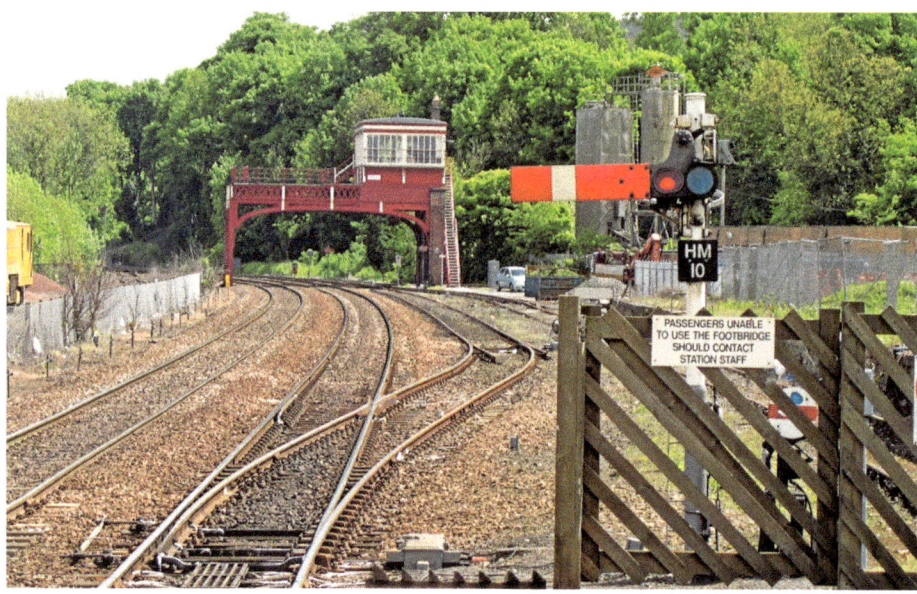

Fig 23. Hexham signal box. The view is towards Newcastle. (May 2006).

NER signal boxes tend to be different to everyone else's and Hexham is an example of the overhead style that saw some use on the Southern Railway and in Ireland, but was not generally in use elsewhere.

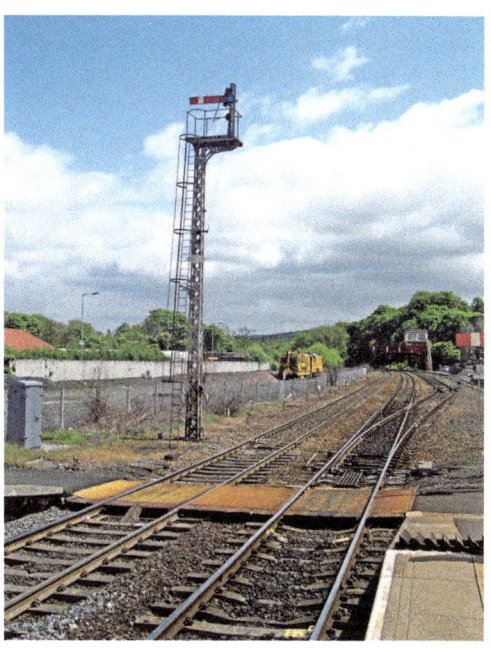

Right: Fig. 24. The very tall lattice post signal is to enable train drivers to see the signal over the platform canopy. This signal was to fall foul of health and safety concerns and has been replaced by a colour light signal. Although there was an extensive goods yard here with livestock facilities, the sidings that remain are for engineering use only. (May 2006).

Below: Fig. 25 is a later view from the Alemouth Road bridge. The tall lattice post signal had been at the end of the Up platform on the left and the colour light replacement is just visible by the footbridge. The station buildings survive in other uses with a splendid café at the earlier survey date. There is a single semaphore signal on the Down side on the other side of the bridge. (November 2015).

Hexham signal box is 20 miles and 53 chains (33.25 km) from Newcastle Central station.

Prudhoe (PE)

Date Built	NER Type or Builder	No. of Levers and/or Panel	Ways of Working	Current Status (2015)	Listed Y/N
circa 1872	NER Type N1	45	AB	Active	N

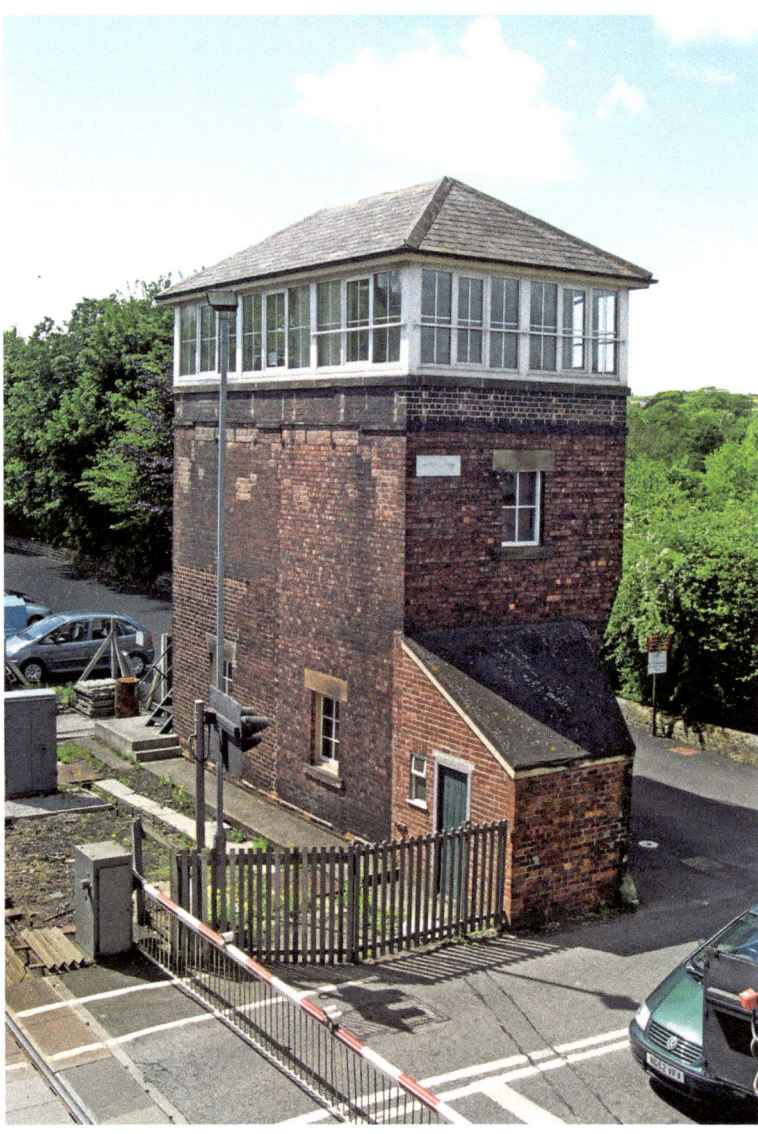

Fig. 26. Prudhoe signal box is another structure that commands a fine view and this time it is beside the tracks rather than over them. Note that the lower part of the box is narrower than the upper and the brickwork has been stepped to achieve this. (May 2006).

The station was never a junction but there were extensive sidings on both sides of the line. Until the date of the first survey two goods refuge sidings existed and are shown in Fig. 27.

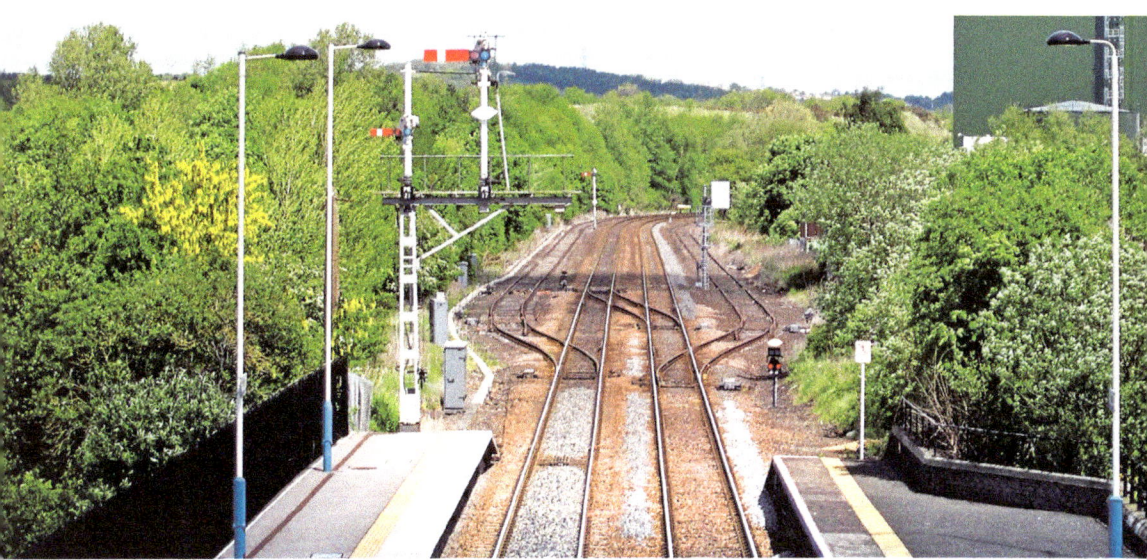

Fig. 27 is the opposite view from Fig. 26 but still on the station footbridge. The two refuge sidings referred to are still here at this time and the bracket signal for the Newcastle direction still has a 'doll' or post with arm to signal entry to the Up siding. The Down refuge siding has been modernised with a double LED ground signal but that is for reversing into the siding from the Down line on the right and over the crossover. The Up siding is driven into. The other signals are section home signals. Note that both refuge sidings have electrically operated trap points at their beginnings. A loop will often have spring-loaded catch points at the end to derail any vehicles that have become detached once the train is inside the loop. (May 2006).

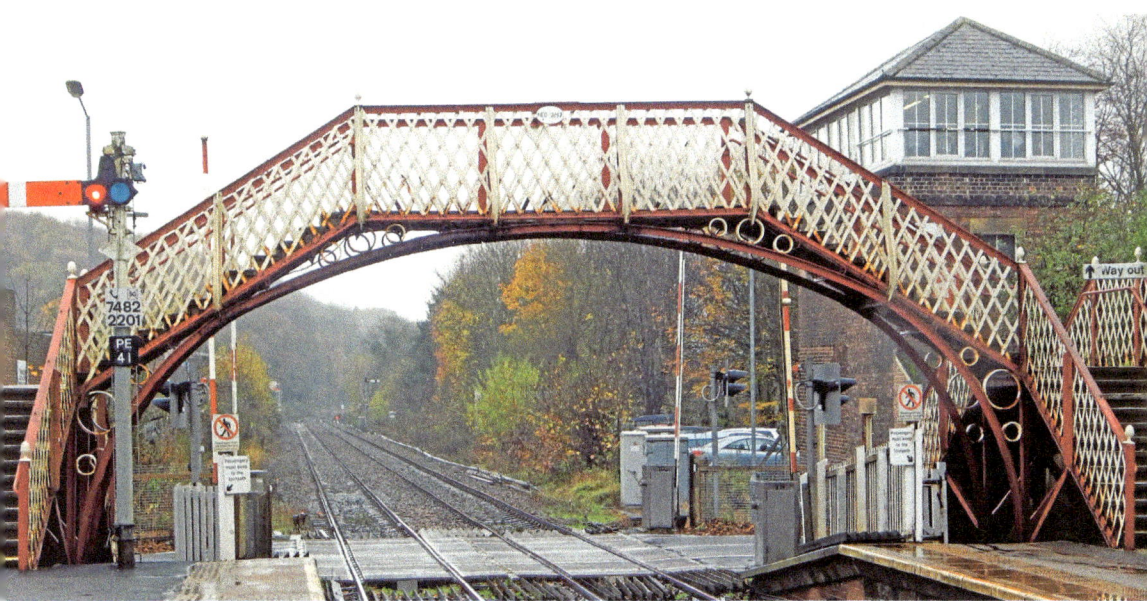

Fig. 28 is the view towards Carlisle and the site of the former station of Mickley on the curve in the distance. Three section signals are on view and an LED ground signal is in the distance. (November 2015).

This is the last of the mechanical signalling before Newcastle.

Prudhoe signal box is 10 miles and 49 chains (17.08 km) from Newcastle Central station.

Wylam (WM)

Date Built	NER Type or Builder	No. of Levers and/or Panel	Ways of Working	Current Status (2015)	Listed Y/N
circa 1897	NER Type N5 Overhead	IFS Panel	AB	Active	Y

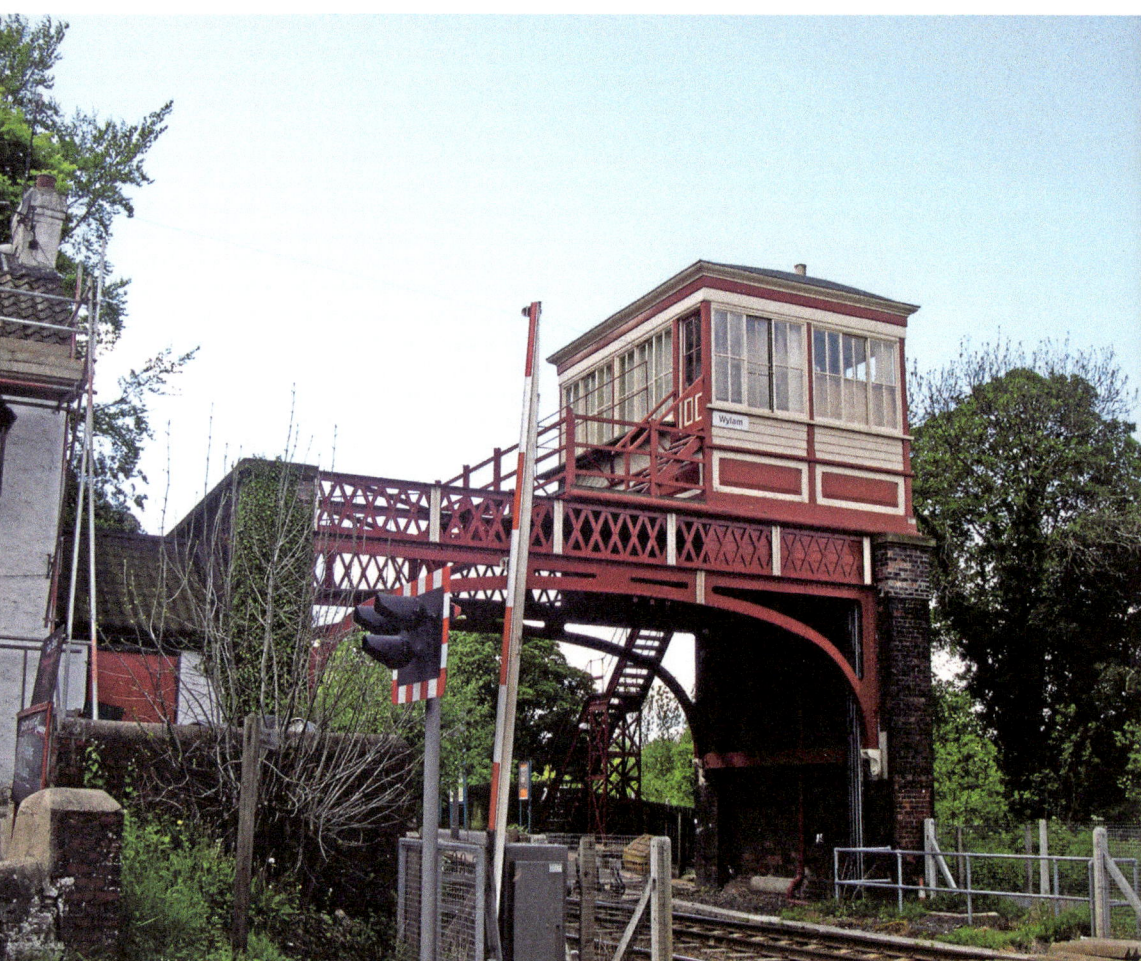

Fig. 29. Wylam signal box. The signal box appears in fine fettle at both survey dates. (May 2006).

The signal box resembles Hexham and is similarly honoured with listing, although there is now no mechanical signalling here, only LED colour lights.

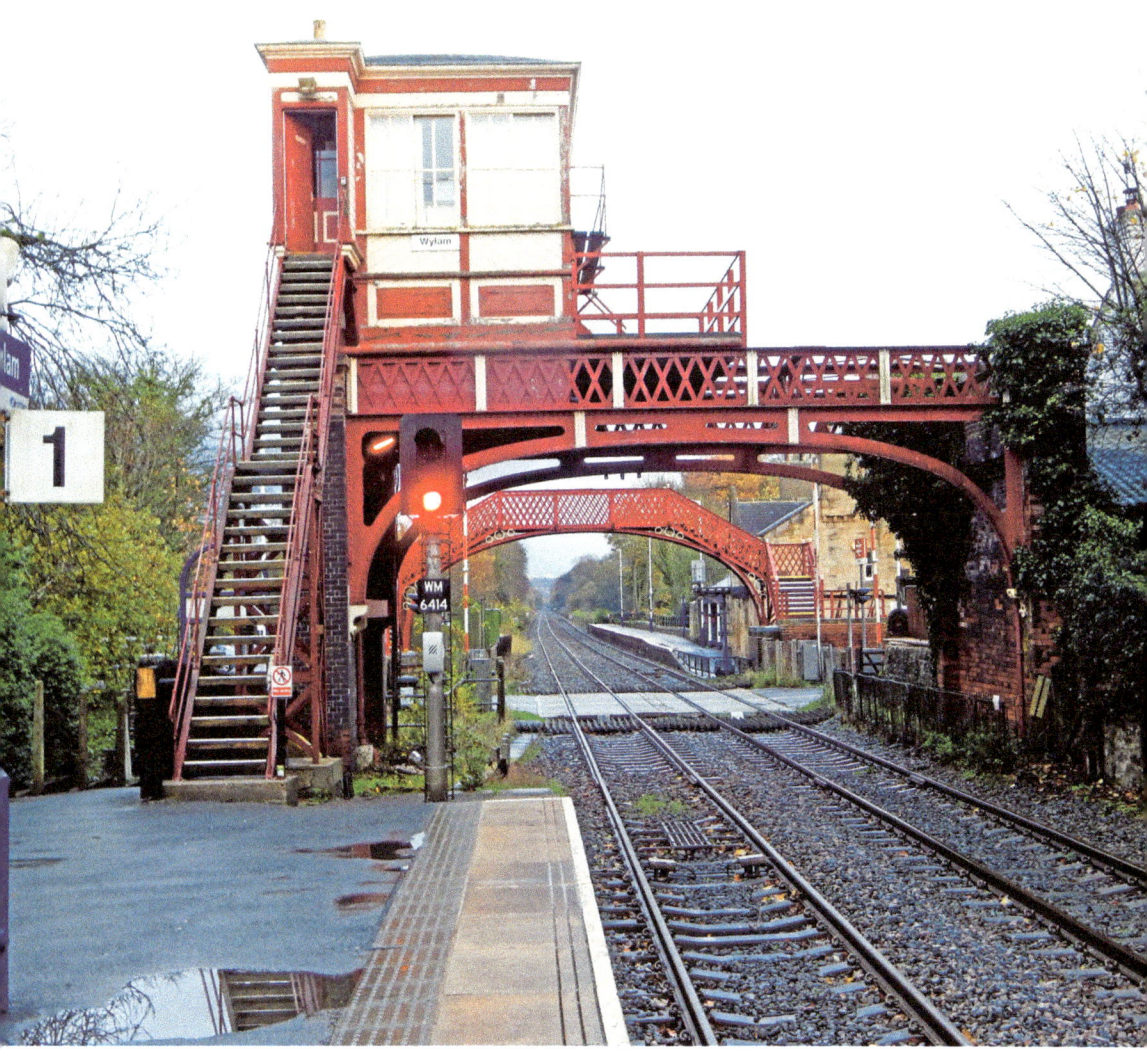

Fig. 30 is a view of the rear of Wylam signal box and yet another entrance door to the box can be seen, which is most unusual. The station buildings pre-date the Victorian era by a couple of years (1835) and are some of the earliest still in use in the world. To complete the set, the footbridge is also listed. The view is towards Newcastle with the Up line on the right. (November 2015).

Wylam signal box is 8 miles and 35 chains (13.58 km) from Newcastle Central station.

Blaydon (BY)

Date Built	NER Type or Builder	No. of Levers and/or Panel	Ways of Working	Current Status (2015)	Listed Y/N
1929	NER Type N2	45	AB	Active	N

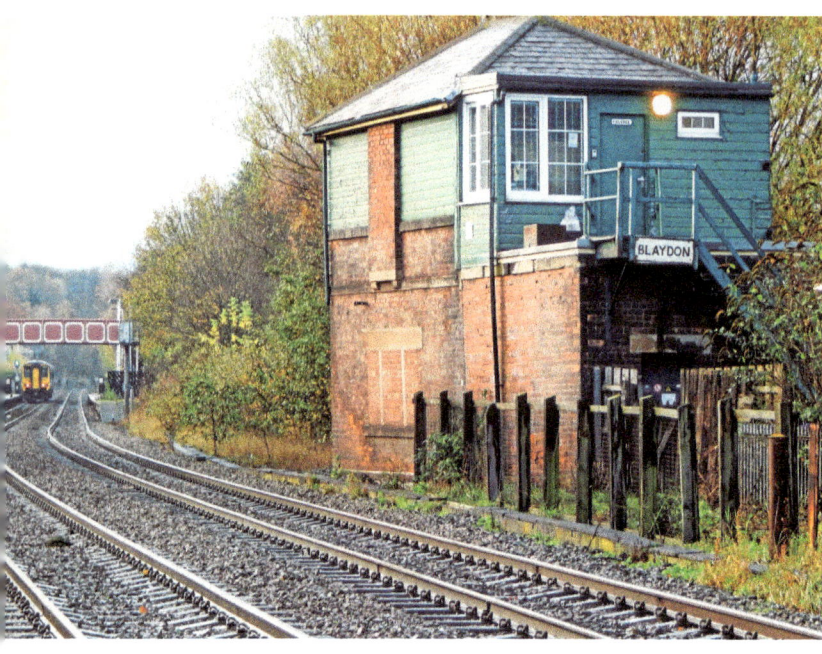

Fig. 31. Blaydon signal box. The Class 156 DMU is on its way to Carlisle and is just pulling out of Blaydon station. (November 2015).

Blaydon signal box was constructed in the 'V' of the lines between Gateshead and Newcastle and so presents a slightly odd appearance today, with the Scotswood Bridge line closing in the 1980s.

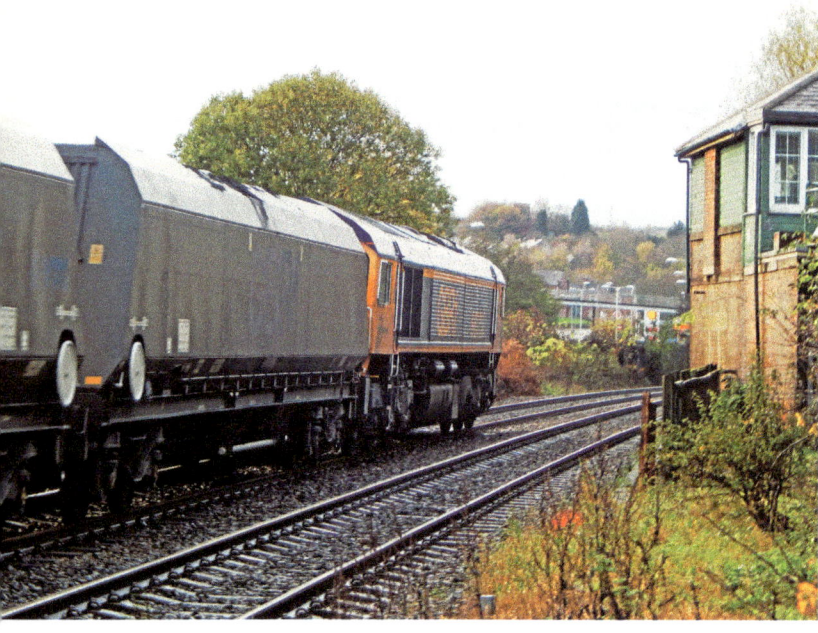

Fig. 32 shows GB Railfreight Class 66 No. 66770 and an empty coal train also on its way to Carlisle. It is almost the complementary shot we saw earlier at Wetheral at the beginning of this journey. The signal box's acute angle to the Newcastle–Carlisle line's tracks is clearly visible here. (November 2015).

26

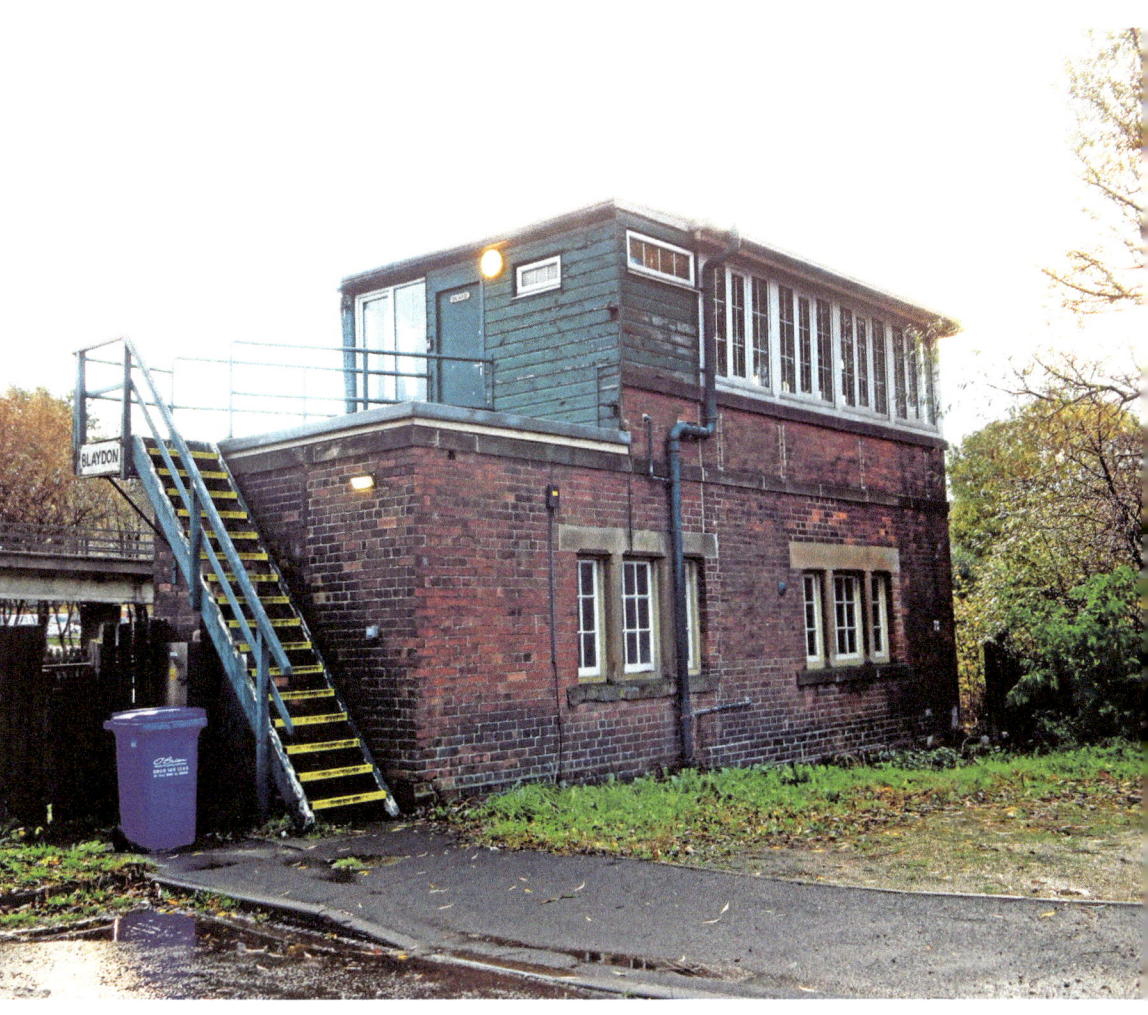

Fig. 33 shows the front of Blaydon signal box and no tracks are present! Since the removal of the Newcastle direct line over the Scotswood Bridge, the box only presents its back to the remaining tracks. The curious shape is due to an extension added in 1911, which was removed in a twenty-first-century refurbishment. (November 2015).

Blaydon signal box is 5 miles and 22 chains (8.15 km) from Newcastle Central station.

Northumberland

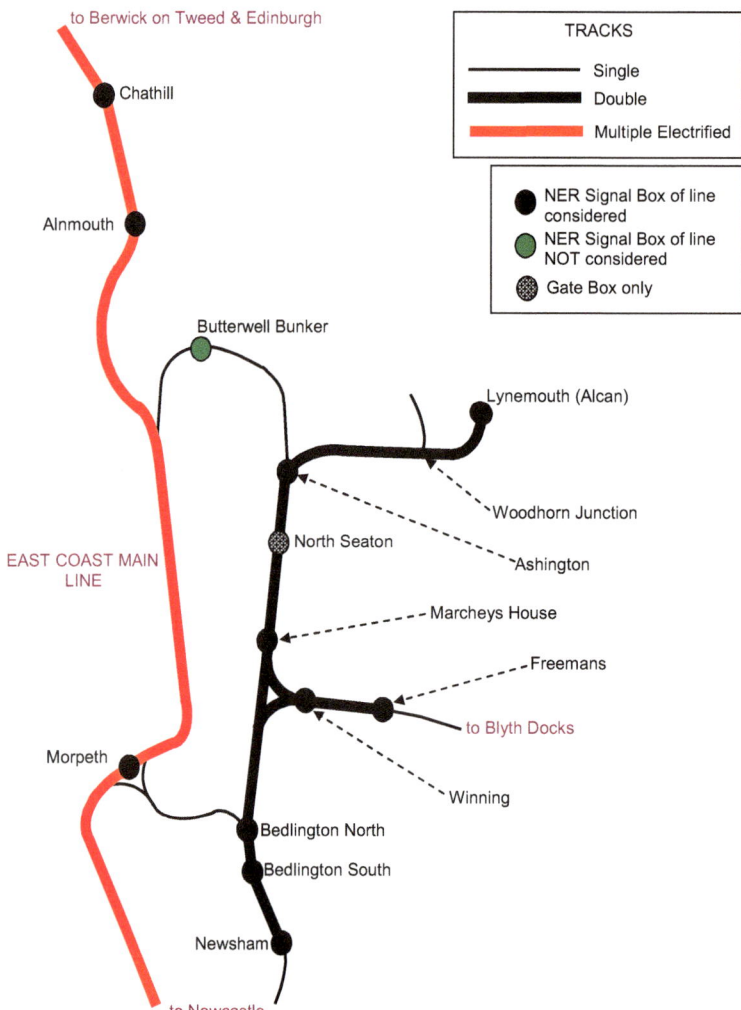

Fig. 34.
Northumberland
schematic diagram.

The schematic not-to-scale diagram at Fig. 34 shows the East Coast Main Line (ECML) striding northwards to Edinburgh. The rest of the tracks, known as the Blyth & Tyne route, are mainly to do with the remnants of the Northumberland coal field and its export, which was, at the survey date, wholly concerned with open-cast mining. The port of Blyth was another of the mass exporters of coal, as was seen with Immingham in a previous volume. There had been two steam sheds at Blyth to handle the coal traffic.

The journeys begin with the branch line towards Blyth from the ECML and associated coal mining lines. The other journey is the ECML, which has no mechanical signalling and only three signal boxes.

Newsham (N)

Date Built	NER Type or Builder	No. of Levers and/or Panel	Ways of Working	Current Status (2015)	Listed Y/N
1945	NER Type N1	20	TCB/AB	Active	N

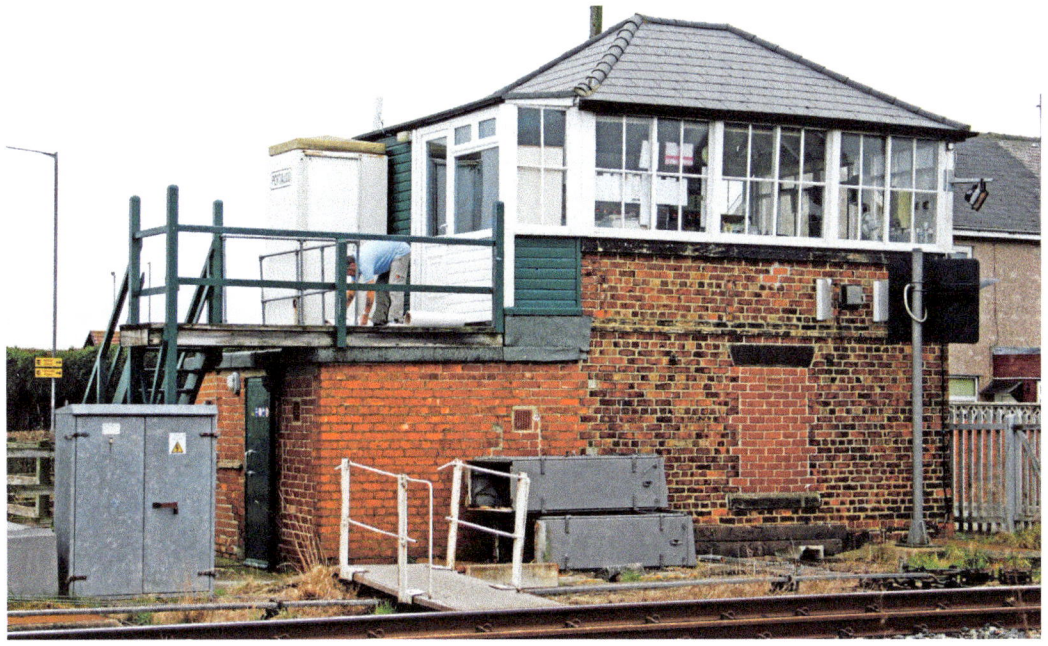

Fig. 35 shows Newsham looking somewhat like Blaydon in the sense that it too has been cut down on the top floor but the lower floor has retained its size – no doubt to accommodate modern relay equipment. This box originally had a much larger frame and gate wheel, followed by BR NER motorised boom gates. It is now barrier gated. The double-track towards Bedlington is deemed the Down direction and towards Newcastle is the Up. (April 2007).

Newsham had been Newsham South and it forms the control point from where the single line from Benton Junction near Newcastle splits into two running lines to a further split at Bedlington.

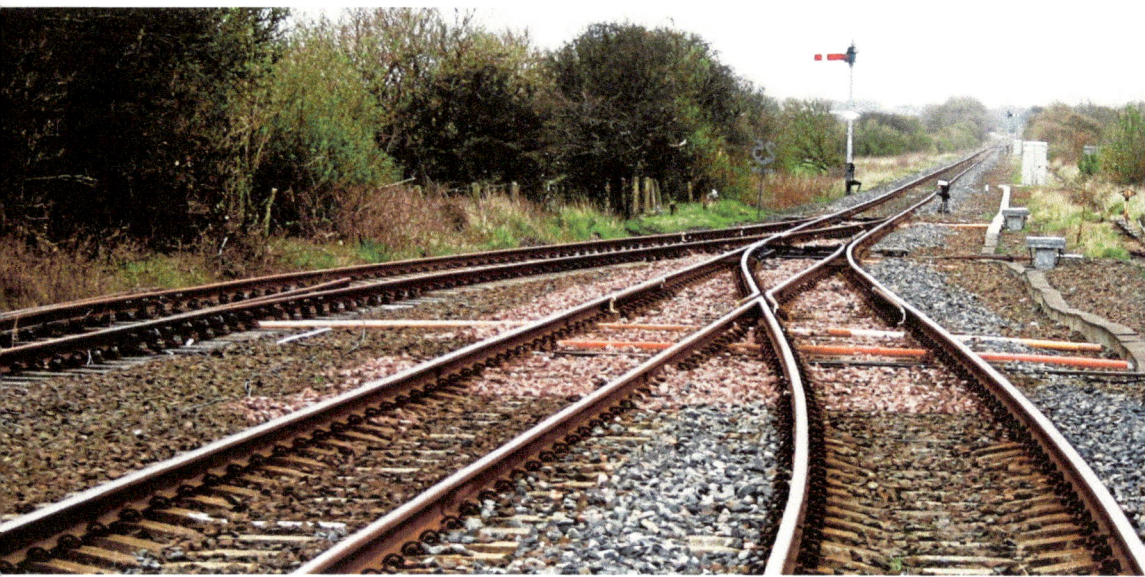

Fig. 36 illustrates the single-track coming in from Benton Junction near Newcastle where the line splits in two to continue as double-track towards Bedlington. The siding on the left is an engineer's siding, complete with trap point. The ground disc signals a move into the siding. Note the cast-iron 0.5-mile (800 metres), two-spiked NER post on the right by the point rodding. The operation up to the home signal on the right is track circuit block from Benton Junction and absolute block thereafter. (April 2007).

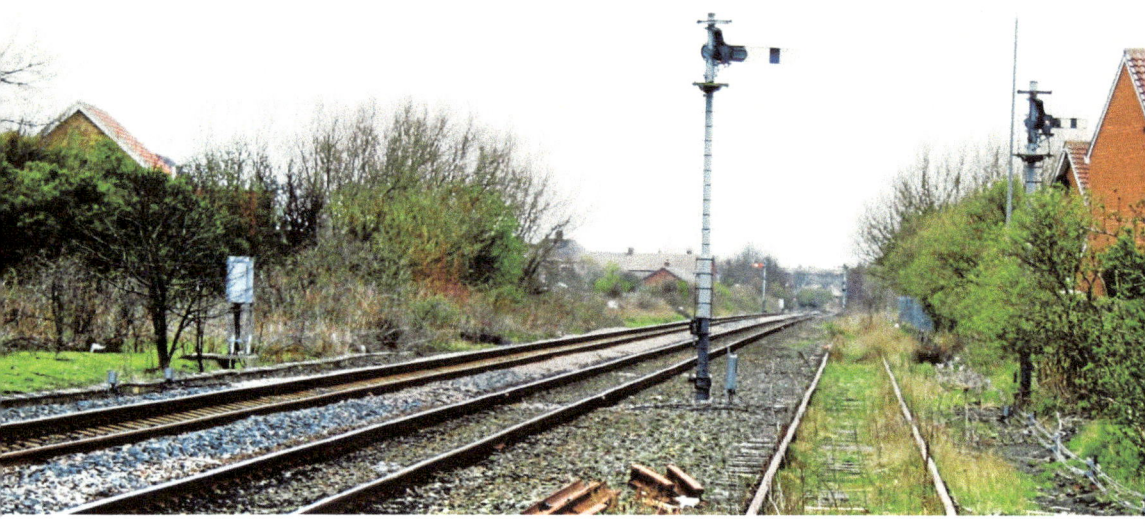

Fig. 37 is the other direction at the road crossing and further up the line on the right was a spur to the Isabella and Bates coal mine rail connection and a connection to Bates Staithes at Blyth Docks. From a short distance along the spur, control passed to RJB Mining. Although the siding still appears connected at the survey date (November 2015), the facilities have been removed. The engineer's siding now on the right looks disused, although its subsidiary starter signal is available to signal a train out onto the main line. The line continues over a viaduct over the River Blyth. (April 2007).

Newsham signal box is 12 miles 45 chains (20.22 km) from Benton Junction near Newcastle.

Bedlington South (BS)

Date Built	NER Type or Builder	No. of Levers and/or Panel	Ways of Working	Current Status (2015)	Listed Y/N
1940	NER Type N1	30	AB	Active	N

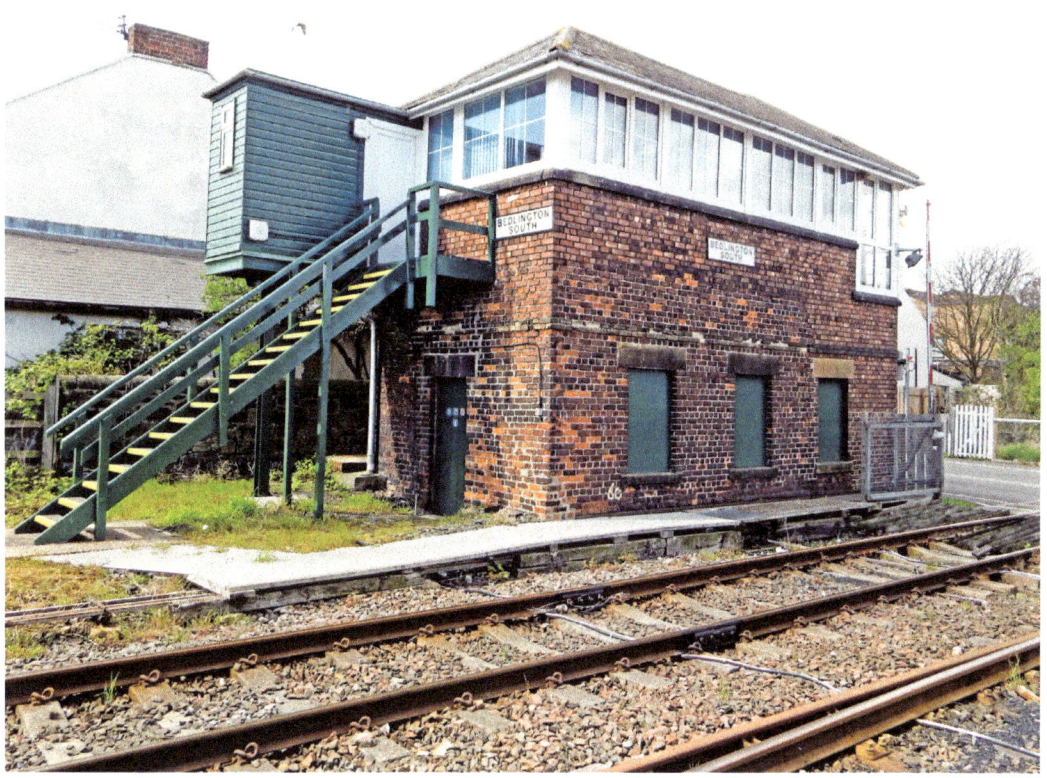

Fig. 38. Bedlington South has been extensively modernised but still retains a wooden staircase and a modified window at the far end that gives the signaller a better view of the traffic approaching the road crossing. (April 2015).

The railway scene is complicated by a double junction towards Morpeth and Blyth Docks and Ashington. This led to two medium-sized signal boxes within sight of one another, separated by a station that was only equipped by a platform on one running line. Into this mix was a junction between the two boxes to Bedlington colliery.

Fig. 39. Bedlington South, furnace sidings. (May 2006).

Fig. 40. Bedlington North signal box and signals. (April 2015).

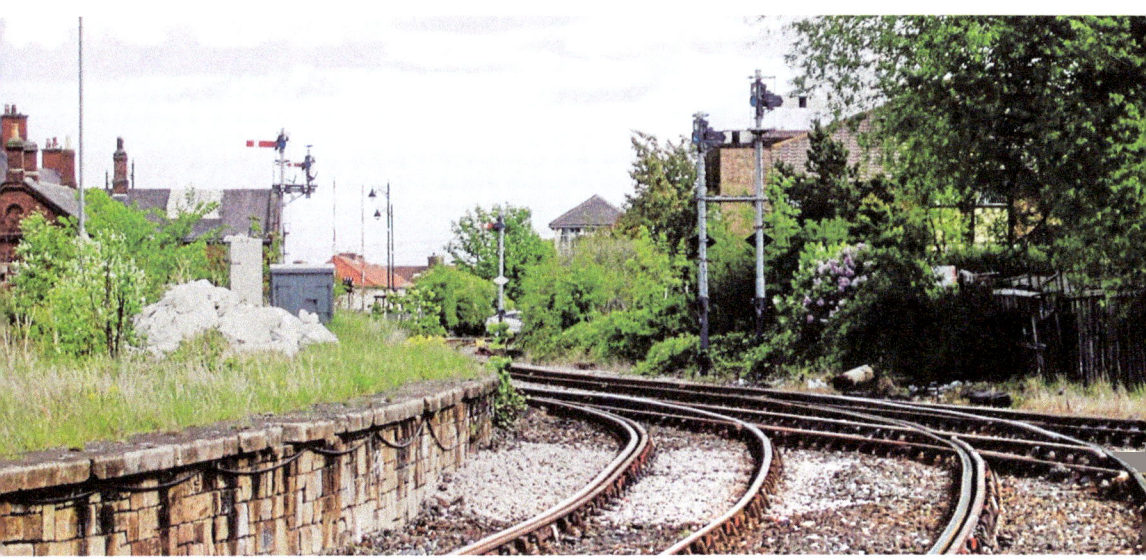

Fig. 41. Bedlington station and signals. (May 2006).

Bedlington South signal box is 15 miles 60 chains (25.35 km) from Benton Junction near Newcastle.

Bedlington North (BN)

Date Built	NER Type or Builder	No. of Levers and/or Panel	Ways of Working	Current Status (2015)	Listed Y/N
1912	NER Type N4+	60	AB/TCB	Active	N

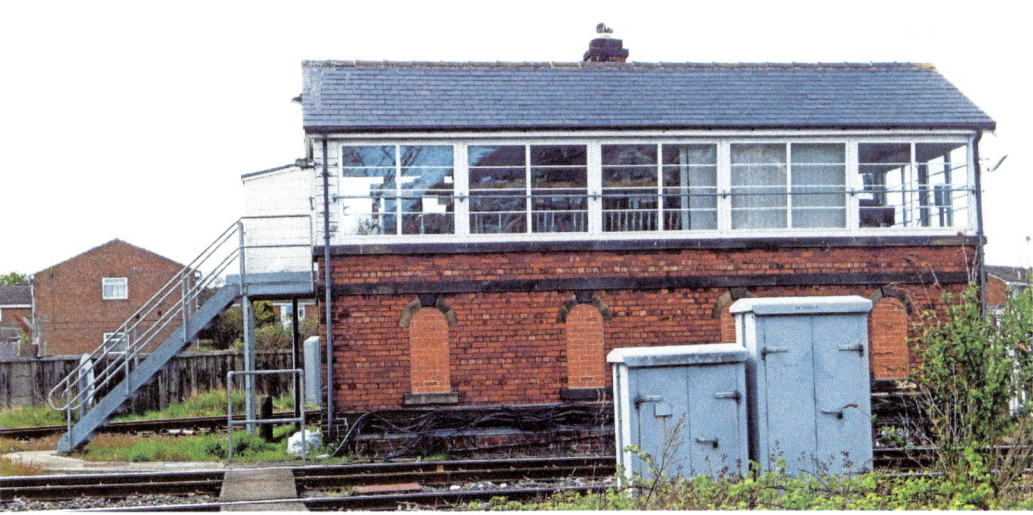

Fig. 42. Bedlington North signal box. (April 2015).

33

Fig. 43. West Sleekburn junction. (April 2015).

Bedlington North signal box is 15 miles 71 chains (25.57 km) from Benton Junction, near Newcastle. Mileages are counted from zero from the Bedlington Junction, outside Bedlington North signal box, towards Blyth.

Marcheys House (MH)

Date Built	NER Type or Builder	No. of Levers and/or Panel	Ways of Working	Current Status (2015)	Listed Y/N
1895	NER Type N2+	15	AB/TCB	Active	N

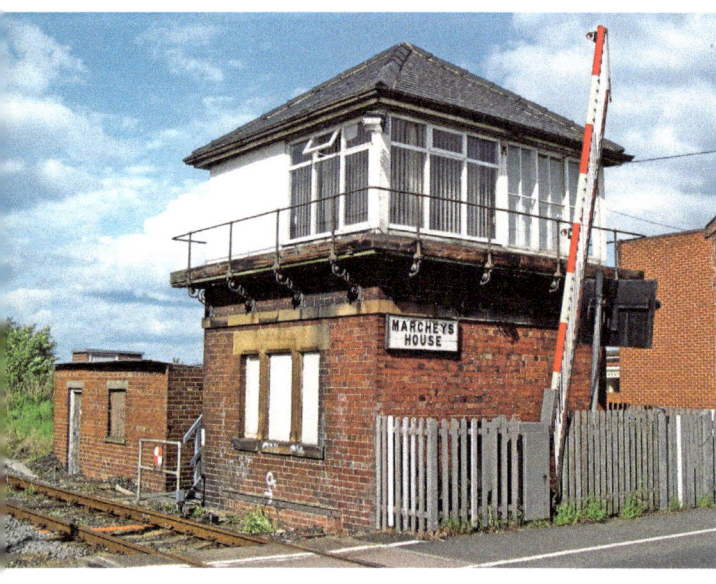

Fig. 44. Marcheys House signal box at Dereham Terrace, Stakeford. (April 2015).

34

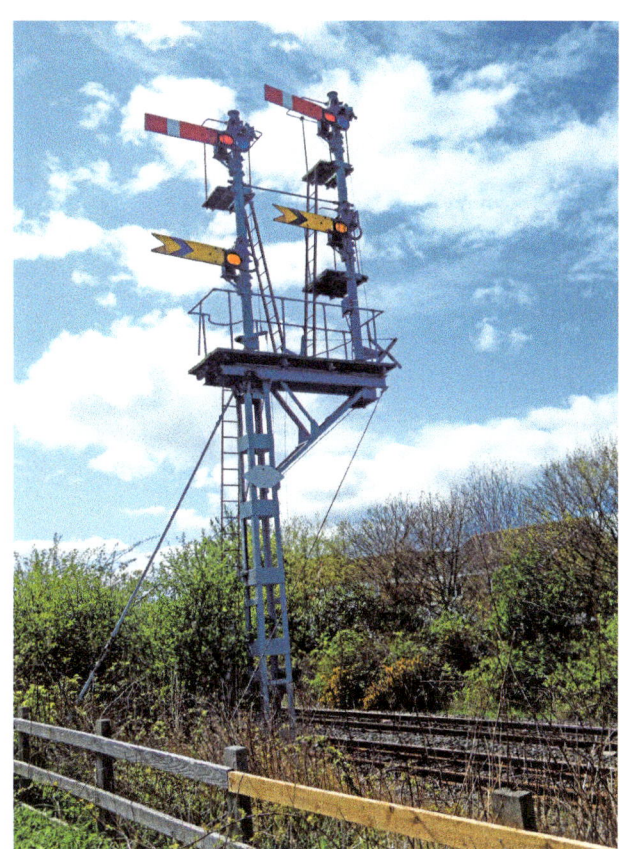

Right: Fig. 45. Marcheys House junction signals. (April 2015).

Below: Fig. 46. Marcheys House signal box towards Bedlington. (April 2015).

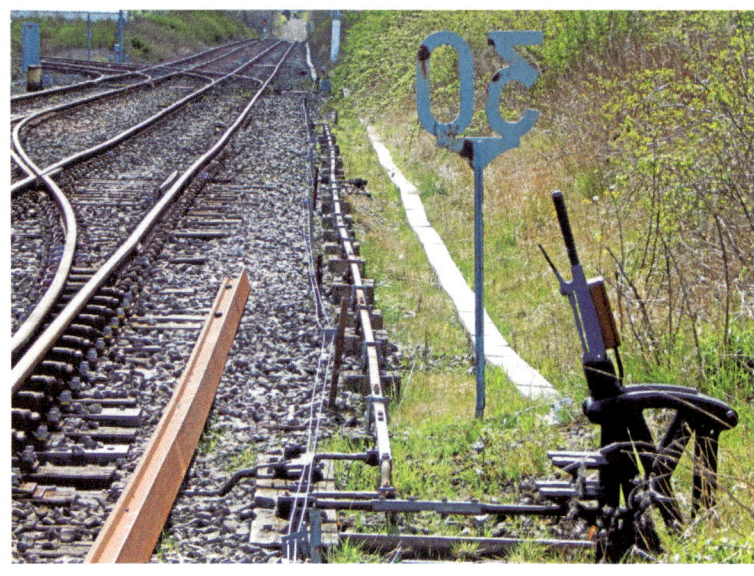

Fig. 47. Marcheys House signal box ground frame. (April 2015).

Marcheys House signal box is 1 mile 41 chains (2.43 km) from Bedlington Junction.

The journey continues past the junctions and over the River Wansbeck.

North Seaton (–)

Date Built	NER Type or Builder	No. of Levers and/or Panel	Ways of Working	Current Status (2015)	Listed Y/N
1872	NER Type Non Standard	21	Gate	Active	N

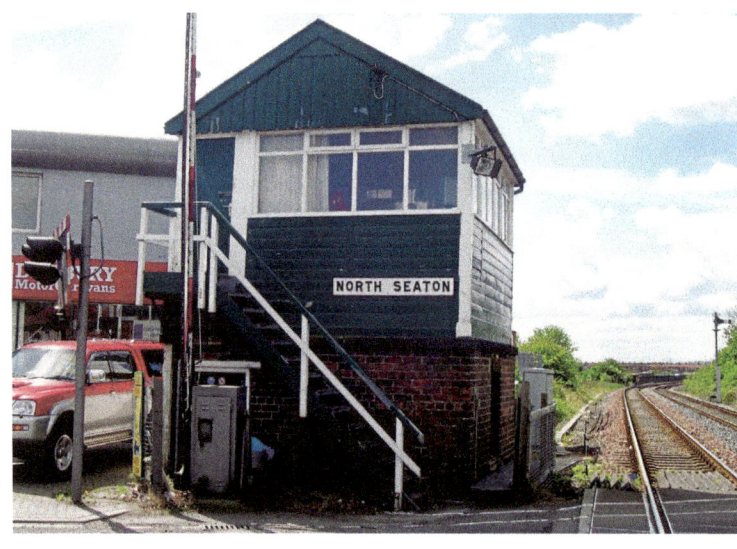

Fig. 48. North Seaton signal box. (May 2006).

Fig. 49. North Seaton signal box, home and distant signals. (May 2006).

North Seaton signal box is 1 mile 76 chains (3.14 km) from Bedlington Junction, near the old station platform.

Ashington (A)

Date Built	NER Type or Builder	No. of Levers and/or Panel	Ways of Working	Current Status (2015)	Listed Y/N
1896	NER Type N1	25	AB	Demolished 2013	N

Fig. 50. Ashington signal box. (May 2006).

37

Ashington is the historic home of the Northumberland coal field as well as famous footballers.

Ashington signal box was 3 miles 5 chains (4.93 km) from Bedlington Junction, near the old station platform.

Lynemouth (–)

Date Built	NER Type or Builder	No. of Levers and/or Panel	Ways of Working	Current Status (2015)	Listed Y/N
1956	National Coal Board	IFS Westinghouse	AB	Active	N

Fig. 51. Lynemouth signal box. (December 2015).

Lynemouth is not a Network Rail signal box but is included as it interfaced to the NR box at Ashington. Lynemouth was the main base for the Alcan aluminium smelting operation and had its own power station. It is the only power station in the area that remains in use.

Lynemouth signal box is 6 miles 12 chains (9.9 km) from Bedlington Junction, near the old station platform.

The journey now retraces its steps to revisit the triangular junction to Blyth.

Winning (WG)

Date Built	NER Type or Builder	No. of Levers and/or Panel	Ways of Working	Current Status (2015)	Listed Y/N
1895	NER Type N2+	15	AB	Active	N

Fig. 52. Winning signal box. (December 2015).

'Winning' was the miner's term for the discovery of a seam of coal before the seam was granted a name of its own.

Signallers down the ages who have worked at the signal box have been subjected to telephone calls to the box to enquire, 'Are you Winning?'

Fig. 53. Winning junction. (May 2006).

39

Fig. 54. Winning signal box crossing. (May 2006).

Winning signal box is 36 chains (0.72 km) from Marcheys House Junction.

Freemans (F)

Date Built	NER Type or Builder	No. of Levers and/or Panel	Ways of Working	Current Status (2015)	Listed Y/N
1956	BR North Eastern Region Type 16b	IFS Panel	AB then TCB/OTW	Active	N

Fig. 55. Freemans signal box. (April 2007).

Freemans sign box controlled the following facilities at Blyth, most of which are now no longer in use:

1. Blyth A Power Station, bunker, run-round and sidings.
2. Blyth B Power Station, bunker, run-round and sidings.
3. Blyth North Staithes coal unloading facility.
4. Blyth West Staithes coal unloading facility.
5. Blyth East Staithes coal unloading facility.
6. Blyth Cambois (pronounced locally as 'Cammus') Traction Maintenance Depot.
7. Alcan alumina importing berth, Blyth Docks.

The coal export facilities were subsequently amalgamated into Departure run-round and Arrival yards in later years.

The signal box worked the North Blyth Alcan berth as the One Train Working system, whereby a train is admitted into the single line section and any further admittance is blocked by the sensing of the train on track circuits within the section. Only when the original train has vacated the section will signals be able to be cleared to admit another train.

Freemans signal box is 1 mile 30 chains (2.21 km) from Marcheys House Junction, which was illustrated in Fig. 196.

The journey now traverses the East Coast Main Line towards the Scottish border.

Morpeth (M)

Date Built	NER Type or Builder	No. of Levers and/or Panel	Ways of Working	Current Status (2015)	Listed Y/N
1978	BR Eastern Region Type 20	Nx Panel	TCB	Active	N

Fig. 56. Morpeth signal box. (March 2007).

The line connects with the Blyth & Tyne route we have just traversed and also supervises the junction from the ECML to Butterwell Bunker open-cast mining disposal point. There had been a block post at Butterwell Bunker inside the loading chute but this was closed some years ago as thieves repeatedly stole the signalling cable.

Fig. 57. Morpeth signal box, single- to double-track. (March 2007).

Morpeth signal box is 16 miles and 63 chains (27.02 km) from Newcastle Central station.

Alnmouth (A)

Date Built	NER Type or Builder	No. of Levers and/or Panel	Ways of Working	Current Status (2015)	Listed Y/N
1907	NER Type N3+	Nx Panel	TCB	Active	N

Almouth station was the junction for the Alnwick branch line, which is being re-built by the Aln Valley Railway Society and their new semaphore-signalled Lionheart station at Alnwick.

Fig. 58. Alnwick signal box. (March 2007).

The branch finally closed, single-tracked, in 1968, but the magnificent train shed, which no doubt pleased the nearby Dukes of Northumberland, survives as Barter Books. Alnmouth had its own loco depot, which was a sub-shed to Tweedmouth, coded 52D, in steam days.

Alnmouth signal box is 34 miles and 76 chains (56.25 km) from Newcastle Central station.

Chathill (–)

Date Built	NER Type or Builder	No. of Levers and/or Panel	Ways of Working	Current Status (2015)	Listed Y/N
circa 1873	NER Type N1+	–	Relay Room	Active in other use	Y

The village of Chathill remains in a time warp.

Chathill signal box is 45 miles and 78 chains (73.99 km) from Newcastle Central station.

Fig. 59. Chathill signal box. (March 2007).

Fig. 60. Chathill station. (March 2007).

Cleveland, Durham Coast and Wearside

Fig. 61. North Teeside, County Durham, Wearside.

The schematic not-to-scale diagram at Fig. 61 shows the railway lines north of the River Tees and continuing up the North Sea coast to Sunderland.

The Stockton & Darlington Railway is considered the first public railway to use steam locomotives in the world and the River Tees, together with the Tyne and the Wear, are three of the most iconic rivers in the country in terms of economic and industrial development. Coal mines, shipping and heavy industry and chemicals made up the portfolio of wealth that the country enjoyed in the nineteenth century. Later years have seen electronics and car-making replace some of the heavier industry.

The journey starts at Stockton-on-Tees in the village of Norton.

Norton West (NW)

Date Built	NER Type or Builder	No. of Levers and/or Panel	Ways of Working	Current Status (2015)	Listed Y/N
1921	NER Type S4	41	AB	Active	N

Fig. 62. Norton West signal box. (April 2015).

Norton has a triangular double-junction that now sees trains mostly down the leg from Norton West to Norton South signal boxes. Norton East box is usually switched out and boarded up.

Fig. 63. Norton West junction signals. (April 2015).

Fig. 64. Norton West junction. (April 2015).

Fig. 65. Norton West junction and a Class 66 with an MGR hopper wagon train. (August 2005).

Norton West signal box is 10 miles and 30 chains (16.7 km) from Ferryhill South Junction.

48

Norton South (NS)

Date Built	NER Type or Builder	No. of Levers and/or Panel	Ways of Working	Current Status (2015)	Listed Y/N
1870	NER Central Division Non Standard	20	AB then TCB	Active	N

Fig. 66. Norton South signal box. (April 2015).

Norton South is peculiar in that the signal box's width is presented to the tracks while the longer length is at right-angles to the track. It has to interface to Bowesfield, which is in TCB territory.

Fig. 67. Norton South junction. (August 2005).

Mileages change here and, somewhat whimsically, Norton South is 61 miles 71 chains (99.6 km) from Wortley Junction near Leeds via Harrogate, Starbeck and Northallerton, some of which are no longer open to traffic.

Norton East (NE)

Date Built	NER Type or Builder	No. of Levers and/or Panel	Ways of Working	Current Status (2015)	Listed Y/N
1870	NER Central Division Non Standard	25	AB	Not Normally Crewed	Y

Fig. 68. Norton East signal box. (April 2015).

Norton East is in the same style as Norton South and is similarly aged.

The box has been switched out on a regular basis for many years now but is maintained and opened up for that purpose. The signals have been replaced in recent years.

Above: Fig. 69. Norton East junction. (April 2015).

Right: Fig. 70. Norton East junction bracket signal. (April 2015).

Fig. 71. Norton East junction signal and Norton on Tees signal box. (April 2015).

As it says on the signal box, Norton East is 62 miles 19 chains (100.16 km) from Wortley Junction near Leeds via Harrogate, Starbeck and Northallerton.

Norton on Tees (N)

Date Built	NER Type or Builder	No. of Levers and/or Panel	Ways of Working	Current Status (2015)	Listed Y/N
1897	NER Central Division Type 2a	26	AB	Active	N

Fig. 72. Norton on Tees signal box. (August 2005).

The Central Division of the North Eastern Railway seemed to favour altitude in their signal boxes but not the overhead type, such as those we saw on the Newcastle to Carlisle route.

Fig. 73. Norton on Tees signal box towards Norton East signal box. (August 2005).

53

Norton on Tees is 62 miles 63 chains (101.05 km) from Wortley Junction near Leeds via Harrogate, Starbeck and Northallerton.

Billingham (B)

Date Built	NER Type or Builder	No. of Levers and/or Panel	Ways of Working	Current Status (2015)	Listed Y/N
1904	NER Central Division Type 2a	50	AB	Active	N

Fig. 74. Billingham signal box. (August 2005).

The signal box marks the spot of the junction to the chemical works sites at Belasis Lane and we will be going down that route shortly.

Billingham on Tees is another NER signal box with the Sir Chris Bonington endorsement for the summit. Access to the box is described as a 'traverse', rather than an entry.

Fig. 75. Billingham signal box junction signals. (August 2005).

Fig. 76. Billingham signal box crossing. (August 2005).

Billingham signal box is 63 miles 60 chains (102.6 km) from Wortley Junction near Leeds via Harrogate, Starbeck and Northallerton.

Belasis Lane (BL)

Date Built	NER Type or Builder	No. of Levers and/or Panel	Ways of Working	Current Status (2015)	Listed Y/N
1904	NER Type S4	25	AB/NSKT	Active	N

Fig. 77. Belasis Lane signal box. (August 2005).

Belasis Lane signal box is situated at the junction where the two tracks from Billingham meet. Afterwards they split again, but to different destinations. The line to Phillips Petroleum sidings is worked No Signaller Key Token.

The No Signaller Key Token system varies from Key Token in that after the token has been issued to the train driver there are no further signal boxes at which to hand in the token and any ground frames are operated by the train crew. A further token apparatus may exist down the line, which may also be operated by the train driver.

The tokens usually contain an Annett's Key, which enables a ground frame down the line to be released or unlocked so that the train driver can change the points.

Once a token has been issued, the token machine is usually locked from a further operation until the token is returned, meaning the train has exited the section. In certain cases a further token can be issued for another train to follow, but only when an electrical interlock has been received, which signals that the original train is securely locked away in a siding.

Fig. 78. Belasis Lane signal box approach signals. (August 2005).

The mileage to Belasis lane signal box is reset to zero at the junction in Billingham and so the box is 1 mile 4 chains (1.69 km) from that junction.

Greatham (GM)

Date Built	NER Type or Builder	No. of Levers and/or Panel	Ways of Working	Current Status (2015)	Listed Y/N
1889	NER Type N1+	21 IFS Panel	AB	Active	N

57

Fig. 79. Greatham signal box. (August 2005).

Greatham is a pretty village near Hartlepool and the signal box was an intermediate block post and crossing at the survey date. However, back to the recent past and Greatham signal box controls the entry to the Hartlepool steelworks, which manufactures pipes.

The steelworks makes pipes up to 68 inches in diameter (1.73 metres), so road transport would be impractical for all but a token load. Part of the pipe-work mill is behind the box. The view is towards Sunderland.

Greatham signal box is 67 miles 28 chains (108.39 km) from Wortley Junction near Leeds via Harrogate, Starbeck and Northallerton.

Cliff House (CH)

Date Built	NER Type or Builder	No. of Levers and/or Panel	Ways of Working	Current Status (2015)	Listed Y/N
1958	BR North Eastern Region Type 17	70	AB	Demolished 2010	N

58

Fig. 80. Cliff House signal box. (August 2005).

The line now moves up the Durham coast and the sea is never far away.

There had been a massive steelworks here and the traffic generated was considerable. The whole area was a mass of running lines, goods loops and sidings for the coal, iron ore, limestone, coke and finished product trains. There had been an elaborate overhead signal box here and its replacement lasted about the same time as the original.

Latterly, the box was retained only for Hartlepool nuclear power station. Nuclear power stations generate radioactive waste that has to be transported by rail to Sellafield for re-processing. Direct Rail Services provide this transport with specially made flasks hauled by at least two locomotives.

Fig. 81. Cliff House signal box signals. (August 2005).

Above: Fig. 82. Cliff House signal box site overview. (August 2005).

Left: Fig. 83. Cliff House signal box derelict signal. (August 2005).

Cliff House signal box was 70 miles 6 chains (112.77 km) from Wortley Junction near Leeds via Harrogate, Starbeck and Northallerton.

Stranton (S)

Date Built	NER Type or Builder	No. of Levers and/or Panel	Ways of Working	Current Status (2015)	Listed Y/N
1911	NER Type N4	30	AB	Demolished 2010	N

Fig. 84. Stranton signal box. (August 2005).

Modern-day Hartlepool has seen the docks transformed into an attractive marina, complete with a Hartlepool-built paddle steamer as its centrepiece.

61

Fig. 85. Stranton signal box signals. (August 2005).

Stranton signal box was 71 miles 22 chains (114.7 km) from Wortley Junction near Leeds via Harrogate, Starbeck and Northallerton.

Clarence Road (CR)

Date Built	NER Type or Builder	No. of Levers and/or Panel	Ways of Working	Current Status (2015)	Listed Y/N
1904	NER Non Standard	36	AB	Demolished 2010	N

Fig. 86. Clarence Road signal box. (August 2005).

62

Clarence is a dominant place name in north Teesside.

Fig. 87. Hartlepool station. (August 2005).

Clarence Road signal box was 71 miles 70 chains (115.67 km) from Wortley Junction near Leeds via Harrogate, Starbeck and Northallerton.

Cemetery North (CR)

Date Built	NER Type or Builder	No. of Levers and/or Panel	Ways of Working	Current Status (2015)	Listed Y/N
1905	NER Type C2a	20	AB	Demolished 2008	N

Fig. 88. Cemetery North signal box. (August 2005).

The box had been switched out in later years and only remained to service a complex of loops and sidings of Britmag Ltd, whose function was to manufacture magnesia for the pharmaceutical industry. The works finally closed in June 2005.

Fig. 89. Cemetery North signal box signals. (August 2005).

Cemetery North signal box was 73 miles 49 chains (118.47 km) from Wortley Junction near Leeds via Harrogate, Starbeck and Northallerton.

Dawdon (DN)

Date Built	NER Type or Builder	No. of Levers and/or Panel	Ways of Working	Current Status (2015)	Listed Y/N
1905	NER Type N3	IFS Panel	AB	Demolished 2010	N

Fig. 90. Dawdon signal box. (August 2005).

Fig. 91. Dawdon signal box, loop and signal. (August 2005).

Dawdon was associated with coal mining.

Dawdon signal box was 84 miles 22 chains (135.63 km) from Wortley Junction near Leeds via Harrogate, Starbeck and Northallerton.

Seaham (S)

Date Built	NER Type or Builder	No. of Levers and/or Panel	Ways of Working	Current Status (2015)	Listed Y/N
1905	NER Type N3+	23	AB Survey Date	Active as Gate Box only Dec. 2015	N

Fig. 92. Seaham signal box. (August 2005).

Seaham not only had local coal mines, some of whose seams went some way under the North Sea, but was also a port to export the coal from.

Right: Fig. 93. Seaham signal box signals and a Class 142. (August 2005).

Below: Fig. 94. Seaham signal box signals. (August 2005).

Seaham signal box is 84 miles 49 chains (136.17 km) from Wortley Junction near Leeds via Harrogate, Starbeck and Northallerton.

Hall Dene (HD)

Date Built	NER Type or Builder	No. of Levers and/or Panel	Ways of Working	Current Status (2015)	Listed Y/N
1905	NER Type N3	21	AB	Demolished 2010	N

Fig. 95. Hall Dene signal box. (August 2005).

The signal box at Hall Dene was extended when it was refurbished in 2005, but that came to nought five years later.

68

Fig. 96. Hall Dene signal box signals. (August 2005).

Fig. 97. Hall Dene signal box signal and a flange greaser, which is the yellow drum-shaped object on the far side of the right-hand tracks. (August 2005).

Hall Dene signal box was 85 miles 24 chains (137.28 km) from Wortley Junction near Leeds via Harrogate, Starbeck and Northallerton.

Ryhope Grange Junction (RG)

Date Built	NER Type or Builder	No. of Levers and/or Panel	Ways of Working	Current Status (2015)	Listed Y/N
1905	NER Type N3	40 + Westcad VDUs	AB then TCB	Active	N

Fig. 98. Ryhope Grange Junction signal box. (June 2007).

The signal box area has been modernised for some years but now, in addition to the 40-lever frame, the box also has Westcad VDUs, whereby from 2010 signallers can view and control the line from Stranton Junction, the far side of Hartlepool, to itself.

Ryhope Grange Junction signal box is 87 miles 63 chains (141.26 km) from Wortley Junction near Leeds via Harrogate, Starbeck and Northallerton.

North Yorkshire, Teesside and Cleveland

Fig. 99. South Teesside and North Yorkshire.

The schematic not-to-scale diagram at Fig. 99 principally regards the south bank of the River Tees, although there are some aspects of County Durham and North Yorkshire noted as connecting strands. The story of coal and heavy industry is continued but, in some cases, in beautiful countryside and delightful locations. The journey starts on the single-track branch line at Bedale in North Yorkshire and this is generally accepted to be near the start of Wensleydale. The main lines have been heavily modernised so only some mechanical signalling remains.

Bedale (B)

Date Built	NER Type or Builder	No. of Levers and/or Panel	Ways of Working	Current Status (2015)	Listed Y/N
1875	NER Type S1a	31	Gate	Active	Y

Fig. 100. Bedale signal box. (November 2015).

Bedale is a charming market town at the head of Wensleydale and on the route of the Wensleydale Railway (WR). The signal box is Network Rail (NR) property but leased to the WR. The line is shared between NR and WR. The line is run using One Train Staff, whereby once a staff is issued, that is the authority to proceed down the branch. The staff must then be surrendered upon leaving the branch. An Annett's Key is attached to the end of the staff and that is used to operate ground frames en route. When a Network Rail train needs to use the route to Redmire, the Wensleydale controller takes the staff by car to the junction with the ECML at Castle Hills and liaison is established by telephone with the signallers at York ROC.

Fig. 101. Bedale signal box, point and signal. (November 2015).

Fig. 102. Bedale signal box, station and signal. (November 2015).

73

Bedale signal box is 7 miles 42 chains (12.11 km) from Castle Hills Junction near Northallerton.

Low Gates (LG)

Date Built	NER Type or Builder	No. of Levers and/or Panel	Ways of Working	Current Status (2015)	Listed Y/N
1956	BR North Eastern Region Type 16b	Nx Panel IFS Panel	TCB	Active	Y

Fig. 103. Low Gates signal box. (January 2007).

There is a junction from the ECML to the Teesside line and that is called High Junction. A loop line dives under the ECML to form another junction with the first and this is called Low Junction. As there was also a crossing there, this location for the signal box was coined as Low Gates. The LNER installed colour light signals on the ECML at Northallerton in the 1930s.

As most of the functionality is remote control it would seem this box's functions would easily be taken over by York at the ROC, but with so much to do this is not obviously seen as a priority as TCB is in operation anyway.

Low Gates signal box is 43 miles and 24 chains (69.68 km) from Wortley Junction near Leeds via Harrogate, Starbeck and Northallerton Low Level.

The journey now heads north towards the Darlington and the Bishop Auckland line.

Shildon (S)

Date Built	NER Type or Builder	No. of Levers and/or Panel	Ways of Working	Current Status (2015)	Listed Y/N
1887	NER Type C2a	42	AB then OTS	Active	Y

Fig. 104. Shildon signal box. (September 2006).

The Weardale line survives to Bishop Auckland and beyond that is the Weardale preserved Railway. The National Railway Museum now has a base at Shildon and much of the original Stockton & Darlington railway buildings are preserved and listed.

75

Fig. 105. Shildon station. (September 2006).

Shildon signal box is 8 miles 26 chains (13.4 km) from the junction for Darlington.

Heighington (H)

Date Built	NER Type or Builder	No. of Levers and/or Panel	Ways of Working	Current Status (2015)	Listed Y/N
circa 1872	NER Type C1	11	AB then TCB	Active	Y

Fig. 106. Heighington signal box. (September 2006).

76

Heighington is close to Newton Aycliffe, which is the site of the new Hitachi train assembly factory that will assemble the next generation of Intercity Express passenger trains. Perhaps it is fitting that the latest in rail transport should rub shoulders with some of the oldest.

Fig. 107. Heighington signal box signal. (September 2006).

Heighington signal box is 5 miles 8 chains (8.2 km) from the junction for Darlington.

Urlay Nook (UN)

Date Built	NER Type or Builder	No. of Levers and/or Panel	Ways of Working	Current Status (2015)	Listed Y/N
1896	NER Type C2a	41	TCB/Gate	Active	N

Fig. 108. Urlay Nook signal box. (January 2007).

Urlay Nook is a village in the Stockton-on-Tees district that had a chemical plant and a site owned by the Admiralty.

Urlay Nook signal box is 7 miles and 39 chains (12.05 km) from Darlington South Junction.

Fig. 109. Urlay Nook admiralty siding and signal. (January 2007).

Bowesfield (B)

Date Built	NER Type or Builder	No. of Levers and/or Panel	Ways of Working	Current Status (2015)	Listed Y/N
1896	NER Non Standard	3 x IFS Panels	TCB/AB	Active	N

In NER days Bowesfield was the busiest signal box on the NER.

Fig. 110. Bowesfield signal box. (January 2016).

79

Fig. 111. Bowesfield signal box and Class 142 DMU. (January 2016).

Bowesfield signal box is 10 miles and 75 chains (17.6 km) from Darlington South Junction.

Tees (TY)

Date Built	NER Type or Builder	No. of Levers and/or Panel	Ways of Working	Current Status (2015)	Listed Y/N
1962	BR North Eastern Region Control Tower	Nx Panel	TCB	Active	N

Fig. 112. Tees Yard signal box. (January 2007).

The yard had its own locomotive depot at Thornaby and when it opened in 1959 it had an allocation of 254 steam locomotives. The Traction Maintenance depot closed in 2008 and was demolished in 2011. Some locomotives are still stabled at the yard.

With the cessation of wagonload freight traffic and freight traffic in general on the railways, the yard closed in stages, but some of it is still active and there is still a wagon repair facility there.

Fig. 113. Tees Yard and Thornaby TMD. (January 2007).

Fig. 114. Tees Yard, Classes 66, 08, 185. (January 2016).

Tees Yard signal box is 12 miles and 70 chains (20.72 km) from Darlington South Junction.

Middlesbrough (M)

Date Built	NER Type or Builder	No. of Levers and/or Panel	Ways of Working	Current Status (2015)	Listed Y/N
1877	NER Type C1	IFS Panel	TCB	Active	N

Fig. 115. Middlesbrough signal box. (January 2007).

Middlesbrough will always be associated with the iron and steel industries and with ironstone in the Cleveland Hills and coal, limestone and the River Tees, the recipe was right for success. Notable achievements were the Dorman Long-built Sydney Harbour Bridge and the Tyne Bridge at Newcastle.

Middlesbrough signal box is 14 miles and 71 chains (23.96 km) from Darlington South Junction.

Fig. 116. Middlesbrough station. (January 2007).

Nunthorpe (N)

Date Built	NER Type or Builder	No. of Levers and/or Panel	Ways of Working	Current Status (2015)	Listed Y/N
1903	NER Type C2b	16	TCB/NSKTR	Active	N

Nunthorpe is effectively an upmarket suburb of Middlesbrough but it controls the working onwards to an end-on junction at Battersby and, from there, on to Whitby.

The working to Whitby is No Signaller Key Token Remote (NSKTR): the signaller issues the token at one end, but the train driver then operates all further token apparatus and there are intermediate sections.

Fig. 117. Nunthorpe signal box. (December 2015).

With NSKTR the train driver is issued with the token at Nunthorpe. After that the train driver can operate the successive token apparatus remotely with no signaller present. This saves on the cost of a signaller plus a signal box down the line. It is only suitable where there is limited traffic on the branch line. Here there are four trains a day to Whitby but seventeen forwards to Middlesbrough.

Nunthorpe signal box is 4 miles and 25 chains (6.94 km) from Guisborough Junction, Middlesbrough.

The line continues to the end on Battersby Junction, where the junction point is operated automatically by the trains on a first-come first-served basis.

The line then passes through lovely scenery along the Esk Valley, wherein Whitby station is 30 miles 61 chains from (49.51 km) from Guisborough Junction, Middlesbrough.

The journey now continues on the line towards Redcar.

Fig. 118. Nunthorpe signal box and bracket signal. (December 2015).

Fig. 119. Nunthorpe station and signals. (December 2015).

85

Fig. 120. Nunthorpe station and a Class 156 DMU. (December 2015).

Fig. 121. Nunthorpe station and a Class 156 DMU departs. (December 2015).

Whitehouse (W)

Date Built	NER Type or Builder	No. of Levers and/or Panel	Ways of Working	Current Status (2015)	Listed Y/N
circa 1874	NER Type C1	40	TCB	Active	N

Fig. 122. Whitehouse signal box. (January 2007).

Whitehouse signal box is in a quieter zone between Middlesbrough and the steelworks' yards around Grangetown. The south bank of the River Tees is littered with rail-connected sites and one such is the North Sidings (even though they are on the south bank), which is controlled from Whitehouse signal box. The sidings are connected to the Up and Down goods lines that bypass Middlesbrough station.

Whitehouse signal box is 15 miles and 76 chains (25.67 km) from Darlington South Junction.

Grangetown (G)

Date Built	NER Type or Builder	No. of Levers and/or Panel	Ways of Working	Current Status (2015)	Listed Y/N
1954	LNER Type 15D	Nx Panel	TCB/OTS	Active	N

Fig. 123. Grangetown signal box. (January 2007).

A lot has been said so far about heavy industry and here it is; Grangetown is right in the middle of the port lines to the steel export terminal, now a container base, Tees bulk handling and Cleveland Potash storage facilities of yards and sidings.

Just along from there, about 1.5 miles (2.4 km) away, is the Redcar Mineral Terminal for the import of coal and iron ore.

This is all behind the box on the banks of the River Tees. In front of the box are:

1. Three sets of Lackenby Grid reception and dispatch looped sidings;
2. The Lackenby steelworks with Basic Oxygen system installation;
3. Various rail-connected workshops, including torpedo ladle facilities;
4. The steelworks locomotive depot;
5. Three internal signal boxes;
6. A rail connection to the chemical sites at Wilton;
7. A rail connection to the Redcar blast furnace site.

Clearly Grangetown does not control all this but it does control traffic flows in and out.

OTS is where the train driver is issued with a wooden staff that has an Annett's Key on the end, which acts as permission to proceed and the ability to operate ground frames en route.

Grangetown signal box is 18 miles and 65 chains (30.28 km) from Darlington South Junction.

Redcar (R)

Date Built	NER Type or Builder	No. of Levers and/or Panel	Ways of Working	Current Status (2015)	Listed Y/N
1937	LNER Type 13	IFS Panel	TCB/AB	Active	N

Redcar was known for a long time as a seaside resort and racecourse but it has been more prominent in the news recently with collapsing steel prices and the closure of the blast furnace. When it was built in 1979, it was the largest blast furnace in Europe.

Fig. 124. Redcar signal box. (January 2007).

The station is a worthy and confident NER structure and although not on the scale of Scarborough or Bridlington, it must have seen many visitors to the seaside.

Fig. 125. Redcar signal box and crossing. (January 2007).

Redcar signal box is 22 miles and 71 chains (36.83 km) from Darlington South Junction.

Longbeck (L)

Date Built	NER Type or Builder	No. of Levers and/or Panel	Ways of Working	Current Status (2015)	Listed Y/N
1932	LNER Type 12	Qty 2 IFS Panels	AB/TB	Active	N

Longbeck station serves the village of Marske-by-the-Sea and this is now commuter country for Teesside and Darlington. The station was only built in 1985.

The signal box has two ways of working, both of which are redolent of a previous age. It works AB to Redcar and Tokenless Block to Crag Hall.

Above: Fig. 126. Longbeck signal box. (January 2007).

Right: Fig. 127. Tokenless Block instrument. (March 2004).

Tokenless Block Operation was introduced by the Western Region of BR in the 1960s to speed up the passage of trains on single lines and obviate the need for physical token swapping at every block or section. It requires the operation and locking of signals electrically and is therefore more suited to colour light signal operation with track circuits, although Tokenless Block Operation exists in semaphore areas too.

Let us suppose that freight train empties from Boulby Mine are to be passed from Longbeck to Crag Hall. The Tokenless Block instrument has three indications possible, of which only one is ever displayed at once and a picture of such an instrument appears at Fig. 127:

1. Normal (line blocked or no permissions granted).
2. Train in Section.
3. Train Accepted.

There is also an Offer button, Accept button and Train Arrived button at both signal box instruments.

To pass the train from Longbeck to Crag Hall, the signaller at Longbeck presses the Offer button and, if Crag Hall selects Accept, this is reflected on Longbeck's Tokenless Block instrument as Train Accepted. This status is also reflected on Crag Hall's TB instrument.

This then locks all the signals on the single line from Crag Hall to Longbeck. In other words, a train cannot pass in the opposite direction to which this train is going unless it passes several signals at danger.

When the train has arrived in the section at Longbeck the track circuits sense this and turn both Tokenless Block instruments at Longbeck and Crag Hall to Train in Section.

When the train has arrived at Crag Hall, complete with tail lamp, the signaller at Crag Hall selects Train Arrived and the instrument indications at both places revert to Normal. This operation is interlocked with any points on the route and the system is then ready to dispatch another train in either direction.

Longbeck signal box is 25 miles and 31 chains (40.86 km) from Darlington South Junction.

Crag Hall (–)

Date Built	NER Type or Builder	No. of Levers and/or Panel	Ways of Working	Current Status (2015)	Listed Y/N
1878	NER Type C1	30	TB/NSKT	Active	N

Crag Hall is the junction where the single-track splits. Slightly to the north is the Skinningrove Steelworks, which still produces custom-designed, hot-rolled, special-shaped steel profiles.

Fig. 128. Crag Hall signal box. (January 2016).

To the south and along the coast somewhat is the Boulby Potash Mine. About 1 million tonnes of ore is mined, which is split off into potash – a fertiliser and rock salt for frosty roads. The potash production is about half of the UK's needs.

The working to Boulby Potash mine is No Signaller Key Token. This system is similar to Belasis Lane, whereby the signaller issues the token and a further token apparatus down the line is operated by the train driver. This enables a train to be locked in a siding down the line and a further train can be dispatched by the signaller towards the safely locked-in first one.

At Crag Hall the Key Token apparatus is by the Down goods loop and at Boulby there is a further instrument in the Mine Supervisor's cabin at Boulby.

Above: Fig. 129. Crag Hall signal box, section home signals. (January 2016).

Left: Fig. 130. Crag Hall signal box, loop bracket signal. (January 2016).

Fig. 131. Crag Hall signal box, section home signals. (January 2016).

Crag Hall signal box is 33 miles and 69 chains (54.5 km) from Darlington South Junction.
The end of the line at Boulby Potash Mine is 39 miles and 8 chains (62.92 km) from Darlington South Junction.

References and Acknowledgements

Acknowledgements

The kindness and interest shown by railway signallers.

References

Books and Printed Works

Allan, Ian, *British Railways Pre-Grouping Atlas and Gazetteer*
Quail Track Diagrams Parts 2 and 4 (TrackMaps)
Rolt, L.T.C., *Red for Danger* (Pan Books)
Signalling Atlas and Signal Box Directory (Signalling Record Society)

Websites

Adrian the Rock's signalling pages
www.roscalen.com/signals

The Signalbox (John Hinson)
www.signalbox.org

Wikipedia
www.wikipedia.org

www.flickr.com/photos/nottsexminer/6903040321
http://signalboxes.com/